D1088611

The Watercolor
Artist's Handbook

The
Watercolor
Artist's Handbook

An essential reference for the practicing artist

Marylin Scott

CHARTWELL
BOOKS

A QUARTO BOOK

Copyright © 2005 Quarto Publishing plc

This edition published in 2016 by
CHARTWELL BOOKS
an imprint of Book Sales
a division of Quarto Publishing Group USA Inc.
142 West 36th Street, 4th Floor
New York, New York 10018
USA

All rights reserved. No part of this publication
may be reproduced, stored in a retrieval system,
or transmitted in any form or by any means,
electronic, mechanical, photocopying, recording
or otherwise, without prior written permission
of the copyright holder.

ISBN: 978-0-7858-3382-6
QUAR.BWC

Conceived, designed, and produced by
Quarto Publishing plc
The Old Brewery
6 Blundell Street
London N7 9BH

Project Editor: Mary Groom
Art Editor and Designer: Tania Field
Photographer: Martin Norris
Picture Researcher: Claudia Tate
Assistant Art Director: Penny Cobb
Indexer: Diana LeCore

Art Director: Moira Clinch
Publisher: Paul Carslake

Manufactured by Modern Age Repro House Ltd,
Hong Kong.
Printed by Toppan Leefung Printing Ltd, China.

Parts of this book have previously been published in
*The Encyclopedia of Watercolor Techniques, 100 Great
Watercolor Tips,* and *The Watercolor Painter's
Pocket Palette.*

Contents

Introduction

Watercolor is a lovely medium, but it is not the easiest one to use, and beginners usually require some help. *The Watercolor Artist's Bible* provides just what you need, in the form of a complete course that takes you from choosing the best paints, brushes and paper to completing finished pictures that you will be proud to hang on your walls.

The book is divided into three sections, starting with Getting to Know the Medium. Here you will find practical advice on choosing the necessary tools and equipment as well as hints on mixing colors—one of the trickier skills to master until you have learned some of the basic properties of color. The second section, Techniques, forms the core of the book and deals with watercolor techniques, from the most basic ones such as laying washes and reserving highlights to some of the more unusual and exciting methods like wax-resist or spattering paint to create texture effects. So, if you have never tried dropping salt crystals into paint, painting with a sponge or drawing into watercolor with a stick, now is your chance to have fun with the medium and discover a range of exciting effects. All the techniques are shown as a series of clear step-by-step demonstrations done by a team of professional artists, with informative captions telling you exactly what to do at each stage. The third section, Subjects, shows the techniques in action.

▲ **Learn about tools and materials**

▶ **Build a basic palette**

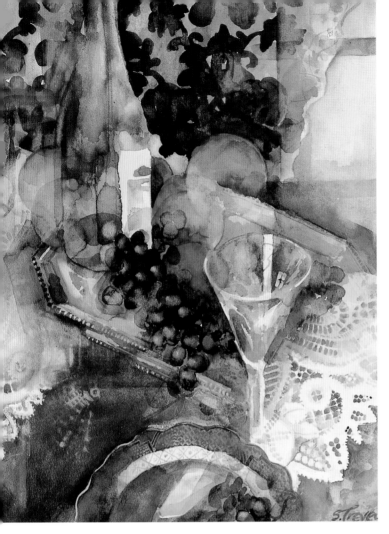

◀ **Look at paintings by established artists**

Finished paintings by a wide range of well-known artists illustrate the diversity of style and subject matter possible with this versatile medium, while text and captions bolster your technical know-how by providing hints on important pictorial topics such as composition and perspective. An added bonus is the selection of specially commissioned "Tutorials," which enable you to follow the artist's progress from the initial planning of the picture through to completion. This chapter is intended to help you learn by example; looking at other people's work is an essential part of any artist's learning curve, and you may find that it helps you toward establishing your own style and becoming confident in handling the medium.

But although developing skills is vitally important, what matters even more is to enjoy what you do and take pleasure in experimenting with different ways of painting, so treat the book as a springboard to launch you into the exciting world of picture making.

▶ **Discover new skills**

1
Getting to know the medium

Watercolor choices

Watercolor paints are sold in tubes, pans and half-pans, both of the latter being designed to fit into a paintbox. You can buy paintboxes complete with around 12 colors—or sometimes fewer—but some people prefer to choose their own colors, as this allows you to start with a smaller range and build up gradually. Whether you choose pans or tubes depends on your style and subject matter. For small paintings done on location, pans are more convenient as the paintboxes come with wells for mixing paint, and you can simply fold up the box on completion. Tubes necessitate a separate palette which can get messy and require cleaning before carrying home. For indoor work, or any large-scale paintings, tubes are best as you can mix up large quantities and strong colors more easily.

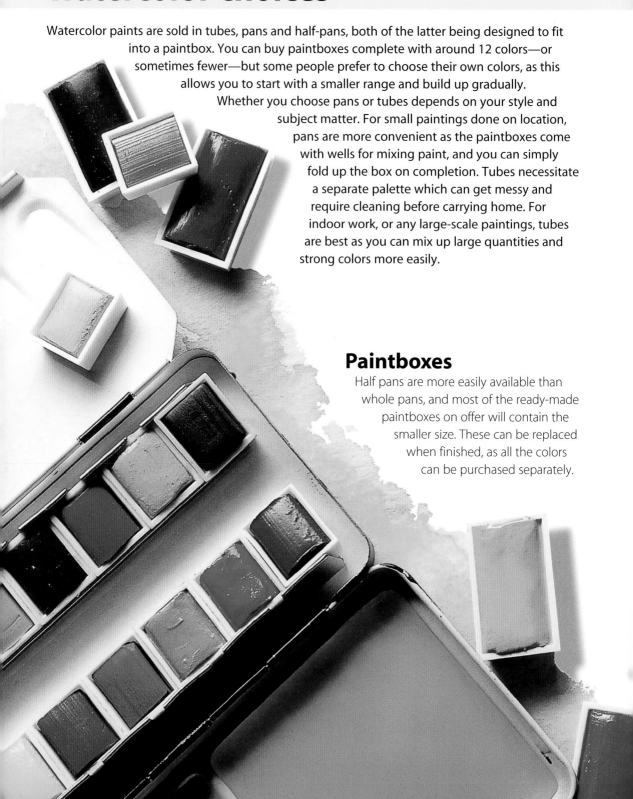

Paintboxes

Half pans are more easily available than whole pans, and most of the ready-made paintboxes on offer will contain the smaller size. These can be replaced when finished, as all the colors can be purchased separately.

Buy the best

Tubes of watercolor are made in a standard size, which may look small in comparison with tubes of oil or acrylic but actually last a very long time. Look for the label "artists' watercolor," and don't be tempted to buy the less expensive paints, known as students' colors, as these contain less pure pigment and may lead to disappointment. This advice also applies to pans of paint.

ARTIST'S TIP

Paints are priced according to the pigment used, with some being much more expensive than others. For initial choices, limit yourself to the less expensive—"special" colors can be bought as needed.

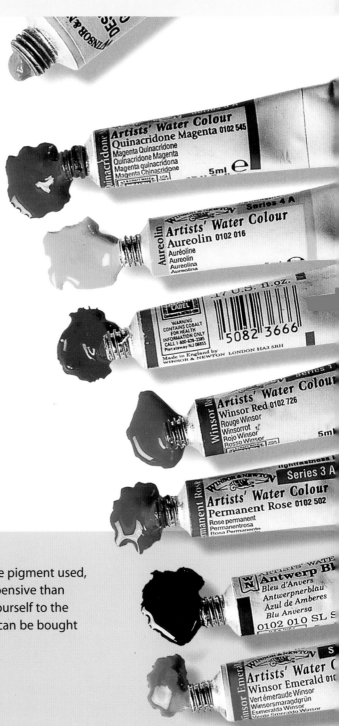

Watercolor papers

If you visit a specialist supplier, you will find a bewildering variety of handmade watercolor papers, but most artists use machine-made papers, which are available from all art stores. These are the best ones to start with, and you can experiment with more exotic papers later if you wish. Machine-made papers come in different surfaces, of which there are three main categories: Smooth (otherwise known as hot-pressed or HP for short); Medium (sometimes called cold-pressed, CP, or Not, for not hot-pressed); and Rough (also cold-pressed, but with a much more pronounced texture).

Although some artists choose smooth or rough paper for special effects, the all-round favorite is Not, which has enough texture to hold the paint but not enough to interfere with color and detail.

If you want to experiment with textures and effects on watercolor paper, use a good, heavy paper or watercolor board, which will take real punishment. A heavyweight paper or board will not need stretching and should soak up a lot of water without disintegrating.

Types of paper
1 Handmade paper
2 Extra rough mold-made artist's board
3 Cold-pressed (Not) paper
4 Rough machine-made paper
5 Hot-pressed (smooth) machine-made paper
6 Rough paper

Stretching paper

Watercolor papers are made in different weights, with the heavier ones obviously being more expensive. Weights of paper are expressed as lbs per ream, with the thickest ones being about 200 lb and the thinner ones below 100. Most sketchbooks contain paper of 140 lb. Thinner watercolor papers (including 140 lb papers if you use a lot of water) need to be stretched so that they don't buckle when paint is applied. This is quite easy, but does have to be done well in advance of painting, as the wet paper takes some time to dry. It is worth doing, however, as trying to lay washes on buckled paper is very frustrating. It's also a way of saving money, as the price difference between thick and thin paper is considerable.

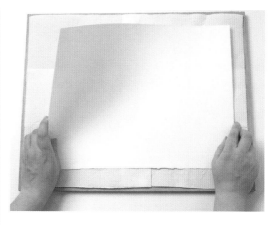

1 Sponging the painting side of the paper can sometimes stir up the surface. To avoid this, smooth some dry paper towels and sponge the back of the paper. The paper towels will absorb any residual water that seeps through to the top side.

2 Lightly sponge the back of the paper, then turn it over and remove the towels.

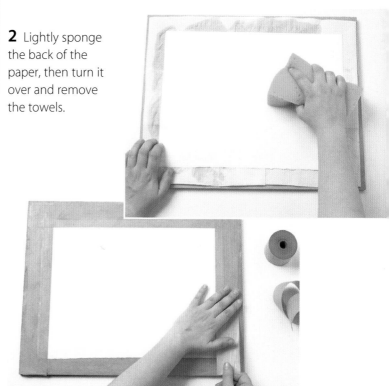

3 Tape down the paper with gummed-paper tape and leave it to dry. You can use a hairdryer to speed the drying time, but don't hold it too near the surface.

Brushes

Most people will know that the best brushes to use for watercolor work are sables. There is no argument about this, but sables are expensive, and there are many excellent synthetic brushes and sable and synthetic mixtures which are quite adequate for most purposes. A good brush should have a certain resilience. You can test the spring of your brush by wetting it into a point and dragging it lightly over your thumbnail. It should spring back, not droop. You also need your brushes to hold a good quantity of water—you can test this easily by moistening it with your mouth. Don't try this with a paint-loaded brush however, as trace elements from the paint can be retained in the body.

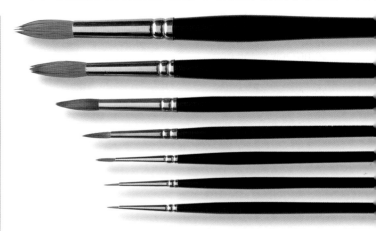

From bottom to top: size 00 round, size 0 round, size 1 round, size 3 round, size 5 round, size 10 round and size 12 round.

Brush sizes

Remember that the larger the brush head, the more paint it will hold, so make sure you have a choice of brush sizes for different applications. However, don't go overboard and buy a whole range—one large, one medium and one small are all that is needed, and some artists use only one brush.

Straight lines

Although long, straight lines can be made using the point of a round brush, for a variety try a "writer" or a "striper," which were traditionally used for this role. Writers are long-haired sables that taper to a point. They are also called riggers, as they were used to paint the rigging on ships. Stripers are long-haired sables which form a chisel edge.

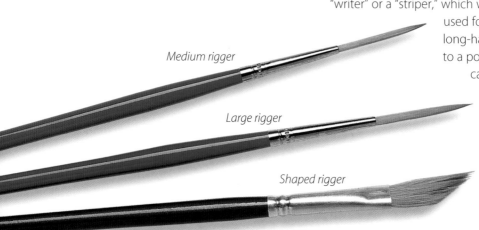

Medium rigger

Large rigger

Shaped rigger

Broad lines

One-stroke brushes, commonly made from synthetic or ox hair, are good for creating broad lines. Short flats and long flats can also be used. They are all chisel-edged and held in flat ferrules. Short flats are especially suitable for applying short dabs of color, while long flats hold enough paint for you to make one stroke across your paper.

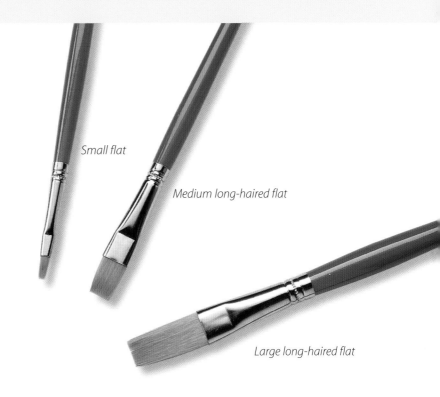

Small flat

Medium long-haired flat

Large long-haired flat

Small long-haired flat

Chinese brushes

If you can only afford a few brushes, Chinese brushes are a wise choice, as they can create a wide variety of different marks and are much less expensive than sable brushes. They are becoming very popular with artists, especially those who like to exploit the marks of the brush in their work.

Continued on next page

Testing brushes

The better the quality of brushes, the better your brushmarks are going to be, so check the quality of any round or pointed brush by painting a fine line with it. The point of a good brush should give a fine line, whatever its size.

1 A good rounded brush will give an equally clean line, but a poor-quality one will quickly fail the test.

2 With a pointed brush, the line created is sensitive and delicate, and can be varied from thick to thin by lessening the pressure.

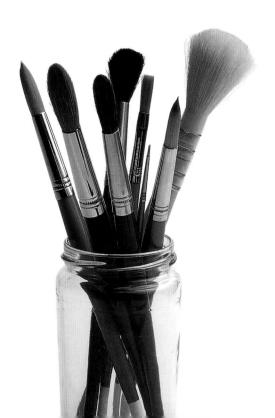

Brush care

At the end of a working session, stand your clean brushes upright in a jar or other container. Never place them downward or you will ruin the bristles. If you are transporting your materials for outdoor work you may find one of the special cylindrical plastic brush holders useful, but make sure the tips of the brushes don't come into contact with the lid as this will bend them.

Water

Water is the vital ingredient in producing a good painting, as you will quickly discover if your water becomes dirty. Always have three pots of water ready when you paint: one of clean water for loading brushes and wetting the paper; one of constantly replaced clean water for mixing with the paint to produce clean, clear colors; and one for rinsing brushes while you work.

Water containers are not pieces of equipment you need to buy, as most artists use recycled jars or yogurt pots, but if you are working outdoor you may find one of the special non-spill plastic containers useful—there is nothing more annoying than spilling your water when you don't have a nearby stream or lake to replenish it.

Clean water for charging brushes before dipping them into the paint.

Non-spill water pots are handy for outdoor work.

Water for rinsing brushes. Always rinse off one color before mixing another.

Water for diluting colors will quickly become dirty, and should be changed before it forms a muddy sediment.

Additional equipment

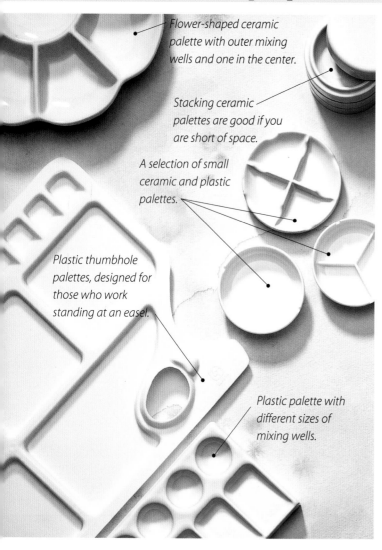

Flower-shaped ceramic palette with outer mixing wells and one in the center.

Stacking ceramic palettes are good if you are short of space.

A selection of small ceramic and plastic palettes.

Plastic thumbhole palettes, designed for those who work standing at an easel.

Plastic palette with different sizes of mixing wells.

Palettes

Watercolor paintboxes containing pans of color incorporate their own palettes, but these do not always provide enough space for mixing, so you may need an auxiliary palette. If you use tubes rather than pans, you will need a palette with recesses to squeeze the colors into and shallow "wells" to keep the mixed colors separate. There is a wide choice of such palettes, made both in china and plastic, and you can also buy small, circular-dish palettes that can be stacked one on top of another when not in use.

Plastic or ceramic *Watercolor palettes are available in plastic and ceramic. The plastic ones are useful for outdoor work, as they are light and easy to carry, but some of them do tend to repel the paint so that it sits in little beads on the surface rather than forming a pool. For studio work, most artists choose ceramic palettes, which are also easier to clean than the plastic ones.*

ARTIST'S TIP

As water is the primary medium for watercolor work, you do not strictly need anything else, but there is one medium that is useful on occasions. This is gum arabic, which is used in the manufacture of watercolor, and can also be mixed with the paints on the palette. This has the effect of giving the paint more body and a slight gloss without affecting its transparency, so that it holds the marks of the brush and becomes more controllable. It is also an aid to the lifting-out technique (see page 50). Never use gum arabic neat, as it may cause the paint to crack. It should be mixed with water, to a proportion of one part gum arabic to three parts of water, or less.

Another medium for watercolor work is oxgall. This is a water-tension breaker that has the opposite effect to gum arabic, helping the paint to flow more smoothly.

Other equipment

A small, natural sponge forms part of most watercolorists' kits. This can be used for washing off paint when a mistake has been made, or for softening edges, as well as for laying washes and lifting-out (see pages 50 and 90).

Another standard item of equipment for many artists is liquid frisket (masking fluid), the easy way to reserve highlights (see page 44).

Finally, you will need pencils for underdrawing (see page 60), boards for supporting the paper, and last but not least, receptacles for holding water. For indoor work, jam jars can be used, but these are uncomfortably heavy for outdoor painting. A variety of light, plastic water containers is available, including a type with a non-spill lid.

Kitchen paper *Ideal for general cleaning-up purposes, and also useful for various lifting-out methods (see page 50) and for blotting off excess paint at the bottom of a wash.*

Masking fluid *This is essential for reserving small highlights that can't easily be painted around. Always use an old brush to apply the fluid, and rinse it immediately, as it is almost impossible to remove from the hairs once dry.*

Sponges *Small, natural sponges are sold in most art stores. They are most often used for lifting out and removing paint, but you can also apply paint with them to build up interesting textures (see page 90).*

Cotton swabs *These are useful for lifting out (see page 50) small areas of dried color, either to make minor corrections or to create highlights.*

Gummed tape *This is used for stretching paper (see page 13). Never try to use masking tape or sellotape instead.*

Pencil and eraser *You will need one or more pencils to make the preliminary drawing, and a plastic eraser to correct any mistakes. Many different grades of pencil are available, but B is a good all-rounder, and is soft enough not to indent the paper.*

Masking tape *If you work on loose sheets of paper rather than sketchpads, tape is essential for securing it to the drawing board. Thumbtacks can be used if the board is relatively soft wood, but won't usually penetrate harder surfaces such as masonite or plywood.*

Choosing colors

You don't need a large selection of colors initially, as it is best to practice mixing from a small range to discover which colors can't be mixed satisfactorily. The first requirement is two of each of the primary colors—red, yellow and blue—as these are made in different versions. Lemon yellow, for example, is more acid and "cooler" than cadmium yellow; cadmium red is a brilliant pure hue while alizarin crimson tends slightly toward blue; ultramarine is a strong "warm" blue, while both cerulean blue and Winsor blue are cooler and slightly more green. You can make a start with just these six colors, but it is useful to have at least one green and a few browns as well. The 12 colors shown here should be adequate for most subjects.

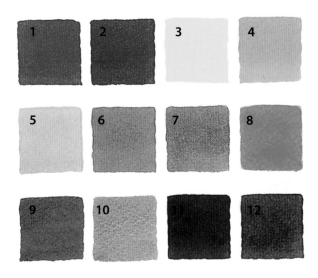

Basic palette

This palette comprises eight primary colors, one secondary, two browns and one gray (the last three are known as tertiary colors). You might add another green, such as sap green, and another brown—raw umber would be a good choice. You also might find that cerulean blue is not essential at first, although it is ideal for painting skies.

1 Cadmium red. *Primary*
2 Alizarin crimsion. *Primary*
3 Lemon yellow. *Primary*
4 Cadmium yellow. *Primary*
5 Yellow ocher. *Primary*
6 Burnt sienna. *Tertiary*
7 Burnt umber. *Tertiary*
8 Viridian. *Secondary*
9 Cobalt blue. *Primary*
10 Cerulean blue. *Primary*
11 Winsor blue (also known as phthalocyanine). *Primary*
12 Payne's gray. *Tertiary*

An enormous range of secondary colors can be mixed with six primaries, but you will need to know which ones to use. As you can see from the color wheel below, each one has a bias toward another, so it makes sense to exploit this. The coolest green, for example, would be made by mixing a greenish blue and a cool yellow. It might be a good idea to make a series of color swatches, trying out different mixtures. This is not only enjoyable but also useful; if you label the swatches and pin them up in your work space they will provide excellent reference—it is easy to forget which colors make the best mixtures. You may also find out that some mixtures of primary colors are less vivid than ready-made secondaries: the purples mixed by the manufacturers, for example, are purer and more vivid than those you can make from red and blue.

The color wheel

This is a highly simplified version of a color wheel, which can include dozens of colors. By placing each of the primary colors next to one another shows the color bias quite clearly.

Cadmium red veers toward orange.

Alizarin crimson has blue bias.

Cadmium yellow veers toward orange.

French ultramarine is slightly purple.

Lemon yellow is acid and greenish.

Winsor blue is slightly green.

Cadmium yellow and cadmium red make a bright, rich orange.

Lemon yellow and Winsor blue create a vivid cool green.

Alizarin crimson and ultramarine make purple.

Intense secondary colors

These examples show how the most intense secondary colors are produced by mixing primaries with a similar bias.

Muted secondary colors

You won't always want vivid mixtures, as some subjects may call for more muted hues. These can be made by mixing primaries with an opposite bias, or combining those opposite one another on the wheel.

Alizarin crimson and lemon yellow produce a muted orange.

Ultramarine and cadmium yellow make a subtle olive green.

Cadmium red and Winsor blue make a slightly gray purple .

Mixing greens

Greens are very easily mixed from blue and yellow, and providing you have a selection of these two primaries you can achieve a very wide range of hues.

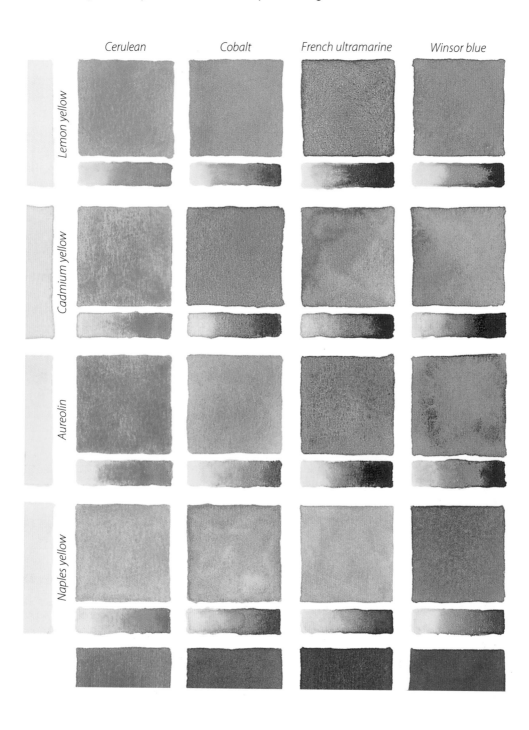

Prussian blue Indigo Viridian Sap green

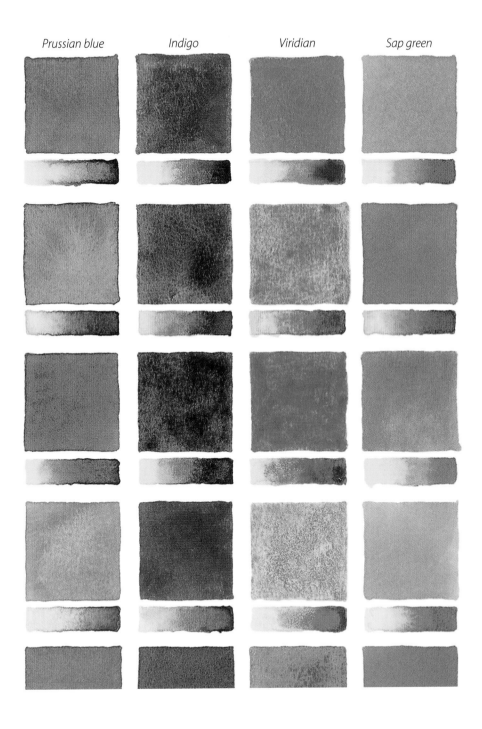

Mixing skin tones

Skin tones can be difficult to mix, as they vary so enormously: from one race to another, within the same racial group, from male to female, and even from one part of the body to another. The variety is made even wider by the light under which a particular person is seen, because skin will reflect light and also take on a certain amount of color from the surrounding hues. Thus, the artist can use a whole range of colors—from yellows and reds in the highlights to blues, violets and greens in the shadows.

Experienced artists have their own favorite mixtures, but beginners often do not know where to start. These pages show five suggested skin-tone mixtures with highlights and shadows for each.

Pale complexion

Main-color mixture

1 *Yellow ocher*
2 *Alizarin crimson*

Highlights show the main color plus

3 *Lemon yellow*
4 *Cadmium yellow*
5 *Cadmium red*

Shadows show the main color plus

6 *Cobalt blue*
7 *Payne's gray*
8 *Viridian*

Sallow complexion

Main-color mixture

1 *Raw sienna*
2 *Rose doré*

Highlights show the main color plus

3 *Lemon yellow*
4 *Cadmium yellow*
5 *Cadmium red*

Shadows show the main color plus

6 *Cobalt blue*
7 *Payne's gray*
8 *Viridian*

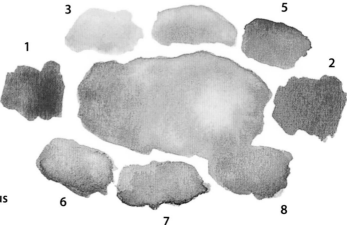

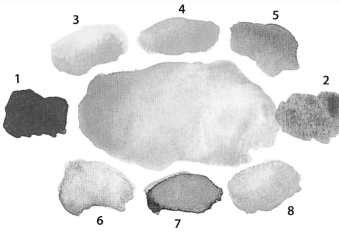

Olive complexion

Main-color mixture

1 *Alizarin crimson* **2** *Raw sienna*

Highlights show the main color plus

3 *Lemon yellow* **4** *Cadmium yellow*
5 *Cadmium red*

Shadows show the main color plus

6 *Cobalt blue* **7** *Payne's gray*
8 *Viridian*

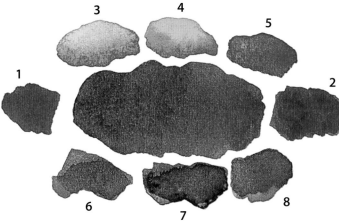

Mid-brown complexion

Main-color mixture

1 *Cobalt blue* **2** *Burnt umber*

Highlights show the main color plus

3 *Lemon yellow* **4** *Cadmium yellow*
5 *Cadmium red*

Shadows show the main color plus

6 *Cobalt blue* **7** *Payne's gray*
8 *Viridian*

Dark complexion

Main-color mixture

1 *Alizarin crimson* **2** *Sepia*
3 *Indigo*

Highlights show the main color plus

4 *Lemon yellow* **5** *Cadmium yellow*
6 *Cadmium red*

Shadows show the main color plus

7 *Winsor violet* **8** *French ultramarine*
9 *Viridian*

Overpainting effects

Newcomers to watercolor often find it difficult to judge the strength and quality of the first color to be applied. There are two reason for this: one is that paint becomes a great deal lighter when dry; the other is that it is hard to judge a color against pure white paper—the first wash inevitably looks too dark or too light.

But don't despair, because you can make changes on the paper itself. A wash that is too pale is easily darkened by applying a second wash of the same color or a slightly darker version of it. You can also change and mix colors on the paper surface: if a pale yellow wash is covered—partially or completely—with a blue one, it will become green, and the tone darkens because there are now two layers of paint.

Permanent yellow down, cadmium red across.

Ultramarine down, permanent yellow across.

Ultramarine (more diluted) down, crimson across.

Permanent yellow with cadmium red down, crimson across (all fairly diluted).

Cadmium red down, viridian across.

Raw sienna down, cadmium red (diluted) across.

Olive green down, raw sienna across.

Olive green down, viridian across.

Olive green down, ultramarine across.

Amending colors

It is surprising how radically even a strong color can be altered by overlaying it with another one. Second and subsequent colors should be applied quickly and surely to avoid stirring up those below.

Transparent and opaque colors

Theoretically, all watercolors are transparent, and it is this quality that characterizes the medium. However, some pigments are slightly more opaque than others, the most transparent colors being the dye-based ones such as alizarin crimson, sap green and phthalo (or Winsor) blue and Payne's gray. Lemon yellow, yellow ocher and cerulean blue are all relatively opaque, so they can be used to lighten the tone of a darker color beneath, or to amend it if required.

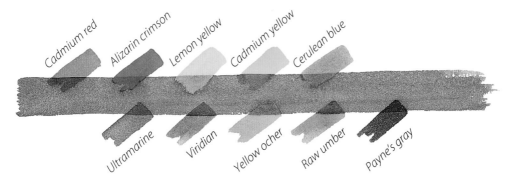

Granular effects

Some colors have a tendency to precipitate, or break up, when water is added, giving a granular, speckled effect. This can be quite worrying when you are new to painting, as you may feel there is something wrong with the paint, or that you have mishandled it, but it is quite normal, and is an effect often encouraged by artists. Granulation is especially obvious when one color is laid over another, and once you get to know which colors have this tendency it is a good way of adding interest and surface texture to an area that might otherwise appear flat and dull. In these two examples, different colors have been laid over first ultramarine and second cadmium yellow.

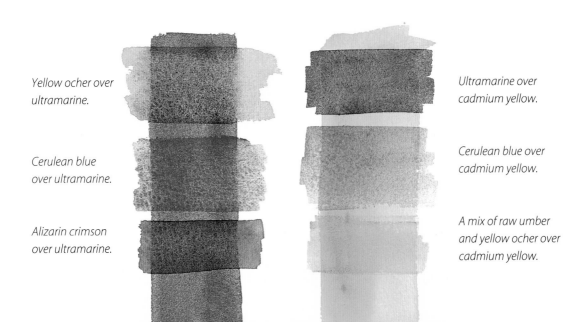

Yellow ocher over ultramarine.

Cerulean blue over ultramarine.

Alizarin crimson over ultramarine.

Ultramarine over cadmium yellow.

Cerulean blue over cadmium yellow.

A mix of raw umber and yellow ocher over cadmium yellow.

2
Techniques

Washes

Beginners to watercolor are usually told that the first skill to master is that of laying a perfect flat wash. In fact, flat washes are not used all that often, but it is part of the learning curve, and once you have mastered the technique you can move on to the more exciting and useful methods of graded and variegated washes and working wet-in-wet. The method is simple; you lay successive bands of color one under the other so that each new band just touches the one above. The board should be propped at a slight angle to encourage the paint to flow downward, and any excess paint at the bottom of the wash can be picked up with a damp brush. Washes can be laid either on damp or dry paper, the latter giving slightly more control but running the risk of possible streaking, so it is worth trying out both to find out which method works best for you.

Wash on damp paper

1 Working on dry paper is best if you want the wash to cover only a restricted area, as you have more control over the paint. For an all-over wash, however, dampening the paper first is helpful. You can do this with either a household sponge or a large brush.

2 The paint will run into any damp area of paper, so that you won't achieve such neat lines of color as with the dry-paper method, but this does not matter.

3 As you continue to work down the paper you will see that the bands of color merge together. Any excess at the bottom can be mopped up with a damp sponge or brush.

4 When the wash has dried it should be perfectly flat.

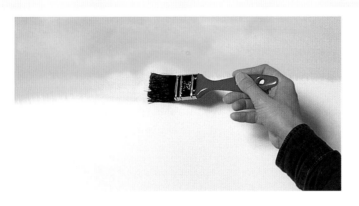

Alternative wash brushes

An old, worn-down shaving brush or a household paintbrush are both very effective for creating really large washes.

Using a sponge

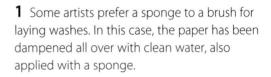

1 Some artists prefer a sponge to a brush for laying washes. In this case, the paper has been dampened all over with clean water, also applied with a sponge.

2 When you sponge on the paint, you apply slightly more pressure than with a brush, and this prevents the paint from running down the wet paper.

3 The slight striped effect visible while the wash was being applied has now disappeared, and it has dried completely flat.

ARTIST'S TIP
When painting washes over large areas, always mix more paint than you think you will need. The wash will be spoiled if you have to stop and mix more paint.

Graded and variegated washes

Graded or graduated washes, which vary in tone to become lighter toward the bottom, are most often used for skies, which are usually darker at the top and paler over the horizon. They are slightly more tricky than flat washes, as the paint must be progressively diluted for each band of color, but there is an easy way to ensure success. Mix up your wash color, lay the first band at full strength, then dip your brush first into the water and then into the paint for each successive band. This guarantees that the wash mixture becomes lighter by the same amount.

Variegated washes are those that change color, and are also used for skies and other landscape subjects. You will need to mix up two or three colors in advance, and make them all of roughly the same dilution—painting a very watery color into a stronger one may cause backruns (see page 64).

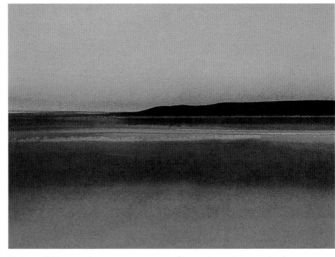

Robert Tilling makes extensive use of broad washes worked on damp paper in his evocative seascapes.

Graded wash on dry paper

Start with a strong solution of color and dilute it progressively until the color is very pale. Tilting the board will encourage the bands of color to flow into one another.

Graded wash on damp paper

This photograph shows the wash being worked on predampened paper. At this stage, the separate bands of color are distinct, but the wash will even out as it dries. The only danger of working on damp paper is that you may lose the graded effect altogether.

Upside-down wash

If a graded wash needs to appear more concentrated in color toward the bottom of the paper, turn the board upside down and start from what will be the bottom, working toward the top.

Variegated wash

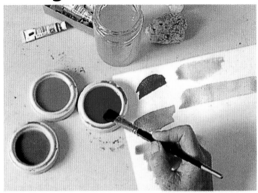

1 Many subjects, especially landscapes, call for a wash containing more than one color. Before you start, mix up all the colors and test their strength on a piece of paper.

2 If you want the colors to blend into one another, dampen the paper first and then lay successive bands of color, quickly rinsing the brush between each one.

3 With the paint still wet, you can see the separate colors distinctly, but they merge as they dry. If you prefer a less blended effect, work on dry paper.

Dropped-in color

Dropping color into a still-damp wash is the basis of wet-in-wet techniques (see page 54). This is an ideal way of working for soft-cloud effects or distant landscape features where you don't want strong definition, as the colors bleed into one another and merge gently. A variation of the method is to drop clear water into just-damp paint, and to create denser effects you could try dropping in diluted Chinese white or white gouache. Experimental washes such as these might form an attractive background for a still life or flower painting, or even a portrait.

White clouds

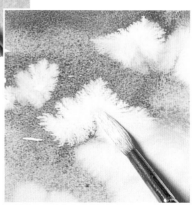

1 Water is dropped into still-damp blue paint.

2 Adding Chinese white or white gouache creates denser effects.

Storm clouds

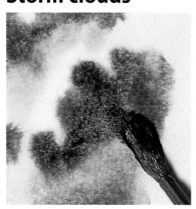

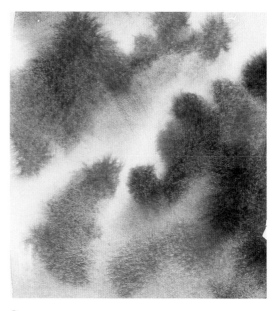

1 Red is dropped into a dark indigo.

2 The colors merge to create patterns suggestive of clouds.

Hard and soft contrasts

In this painting, the sky has been achieved by dropping in a mixture of cobalt blue and cerulean onto damp paper. To provide a sharper focus in the foreground, the paper has been allowed to dry and the trees painted crisply wet-on-dry (see page 52).

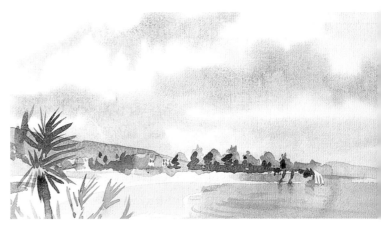

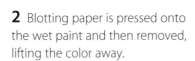

1 The wash is first flooded with water.

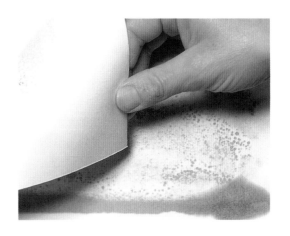

2 Blotting paper is pressed onto the wet paint and then removed, lifting the color away.

ARTIST'S TIP

Exciting cloud effects have been created by dropping in deep grays and reds onto a base color of pale yellow and tilting the board to encourage the flow of paint both downward and sideways. The bands of color at the bottom of the picture have been left to dry naturally, so that they form intriguing jagged edges.

Brushwork

Although paintings can be built up entirely in a series of flat washes, brushmarks can be very important in watercolor painting, making all the difference between a lively, dynamic painting and a dull, static one. Aim at making the marks of the brush describe the shapes you are painting: foliage, for example, can usually be described in a series of one-stroke marks, as can the ripples in water. In general, the most versatile brush is the round, which (if good quality) makes a good point and can achieve very varied effects from fine lines, dots and squiggles to large shapes—but you might also try flat brushes, which can be used on their sides as well as at their full width.

Loosening up

Holding the brush near the top of the handle encourages a looser, freer approach with more expressive strokes. Another trick is to work standing up so that you are forced to make wrist movements rather than just moving your hand.

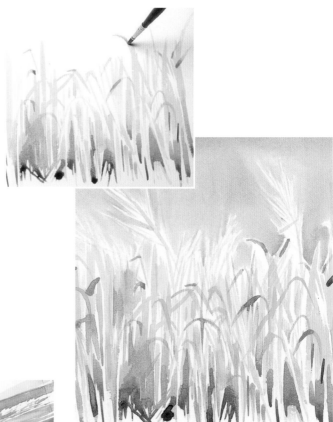

Varying the strokes

A large, round brush allows you to make highly descriptive shapes by varying the pressure. You can either start the stroke with the tip, working lightly at first and then pressing the brush down more firmly, or you can reverse the process, drawing the paint out at the end of the stroke. Here, the artist uses a combination of both methods.

Fine lines

There is always a temptation to reach for a tiny brush when outlining shapes, but the point of a large brush gives much more varied effects.

Dots and dabs

Here, fine lines are drawn out into a series of small dots, becoming paler as the brush is progressively "starved" of paint.

Analysis **Brushwork**

Paul Talbot-Greaves Fall Trees

The challenge here is to convey the fragmented light filtering through the woodland leaves as they start to change color in the fall. The light is described through the strong contrast of the dark tree trunks against the sun-lit foliage. The artist has used a combination of blocking, detailed brushwork, and stippling and spattering techniques in the painting. Well-controlled stippling and spattering suggest the filigree leaf canopy without going into detail. An old brush with a round, blunt tip is ideal for applying this technique as it can deliver large blobs of paint to the paper.

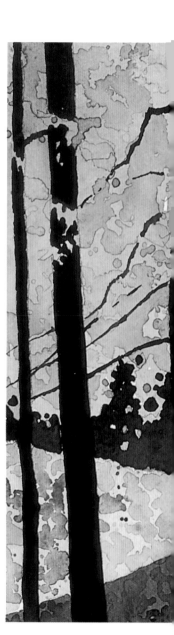

The controlled use of spattering and stippling techniques create depth in the tree canopy and random ground texture.

The leaf canopy is initially blocked in with a size 8 brush.

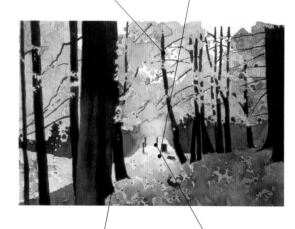

The forms of the tree trunks are outlined by negative painting.

Finer details are added with a size 4 brush.

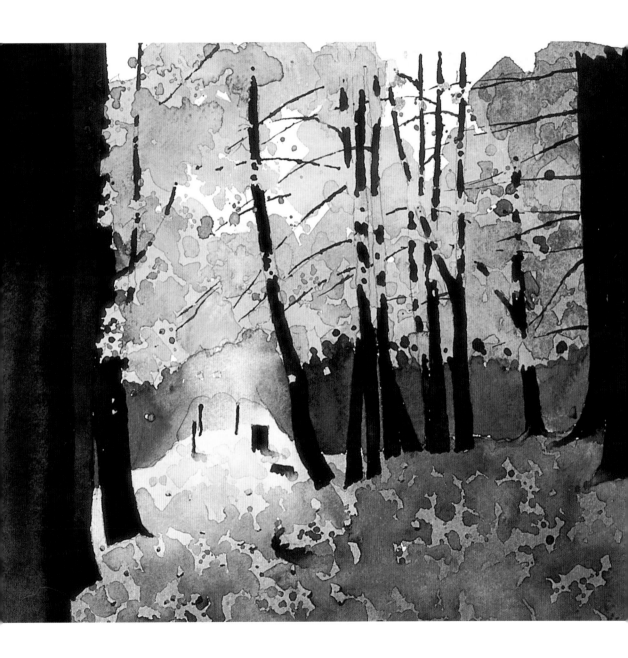

Blending

Blending means achieving a soft, gradual transition from one color or tone to another, and is the primary means of describing form. It is a slightly trickier process with watercolor than with oil or pastel, as watercolor washes dry with hard edges if left alone. But this is not a problem, as edges that form where one wash meets another can very easily be softened by brushing or sponging lightly with a damp brush or sponge. Alternatively, you can create soft blends by working with the paint fairly dry and applying it in small brushstrokes rather than washes.

The wet-in-wet technique (see page 54) is another way of creating soft blends and is ideal for amorphous shapes such as clouds, but is less suited to precise effects such as those you might need in portraits, because you cannot control it enough. You could, however, work wet-in-wet in the early stages, or for some areas of the picture.

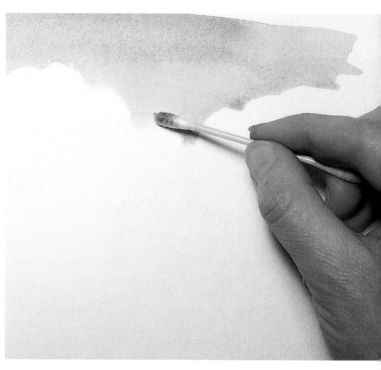

Softening edges

If soft features such as clouds or the edges of trees look too strong against a wash, use a cotton swab or damp brush to soften them. This is best done when the paint is still damp, but it is perfectly possible to soften edges in dry paint also.

ARTIST'S TIP

When blending colors by laying one over another, beware of using too much water as blotches and backruns may form (see pages 62 and 64). Use the paint as dry as possible, and moisten the edge of each new patch or band of color with the tip of a clean, damp brush.

Modeling form

1 In order to achieve a softly blended effect, the artist paints the dark shadow of the fruit wet-in-wet, but has let the first wash dry slightly first so that the new color does not spread too far.

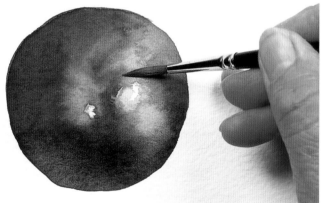

2 When the paint is completely dry, she builds up the form of the fruit, using a fine brush and making a series of small brushstrokes of fairly dry paint.

3 As a final touch, a wash of Payne's gray is added for the shadow under the fruit, so it does not appear to float in space. Shadows play an important role in conveying the solidity of an object.

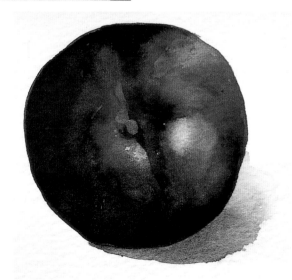

Reserving white paper

The light reflecting off white paper is an integral part of a watercolor painting, giving good watercolors their lovely translucent quality. For this reason, the most effective way of creating pure, sparkling highlights is to "reserve" any areas that are to be white by painting around them. This means that when you begin a painting, you must have a clear idea of where the highlights are going to be, so some advance planning is necessary.

Not all highlights are pure white of course: in a painting where all the tones are dark, too many whites could be over-emphatic. Before the painting has advanced very far, you will have to decide whether to reserve areas of an initial pale wash or to build up really dark tones around a later, mid-toned one.

Small highlights—such as the points of light in eyes or the tiny sparkles seen on sunlit, rippling water, which are virtually impossible to reserve—can either be achieved by masking (see page 44) or by adding a thick Chinese white or zinc white gouache paint at a final stage.

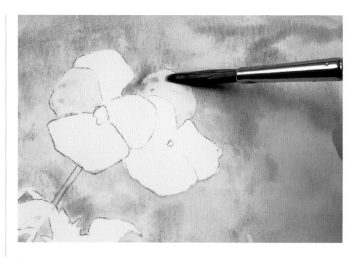

1 To ensure that highlights will not be lost when washes are added, the artist has begun with a careful drawing before painting wet-in-wet washes around the flower heads.

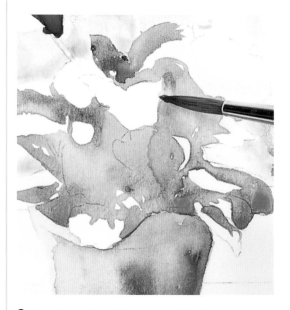

2 She has painted the pots while the background was drying and now starts on the leaves, again working wet-in-wet and leaving patches of white paper for highlights.

3 The deep-colored centers of the petals are painted with sure brushstrokes, using the point of a round brush.

4 In order to attach the pots to the surface so that they don't appear to float, she paints shadows beneath them, using a mixture of ultramarine and sepia. The same mix is used for the shadow along the inner edge of the tray.

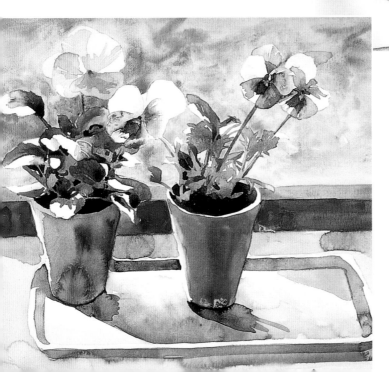

5 The flower heads have been worked up with yellows and violets, leaving the light-catching petals white. The strong shadows and highlights on the petals, leaves and pots create a powerful sense of light flooding the whole scene.

Masking highlights

If you have difficulty painting highlights without spoiling the edges of the shapes, liquid frisket—or masking fluid—is a great help, as it is designed especially for the job. Apply before the washes are put on, allow to dry and then paint over it. This allows you to work freely, exploiting loose washes and wet-in-wet (see page 54) techniques without the worry of paint splashing over the edges of a white area. The fluid can be removed at any stage in the painting, and can thus produce pale-colored highlights as well as pure white. If you peel it off at a halfway stage and then build up further washes over the picture, the once-masked areas will remain lighter than the surrounding areas.

The two great advantages of masking fluid is first that it allows you to make very small highlights such as points of light on water, and second, that it is a way of painting in "negative," and you can exploit the shapes of the brushmarks just as you do when painting with color.

1 Masking fluid has been applied with a small brush and allowed to dry before a wash is laid on top.

2 The wash has been deepened in the nearer area of water and again allowed to dry before the fluid is removed by rubbing with a rag. You can also use your finger or a plastic eraser.

Random masking

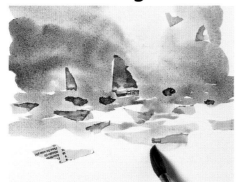

1 Pieces of torn newspaper can also be used for masking, and are excellent for random white areas. For crisp effects, do not remove the paper until the washes have dried.

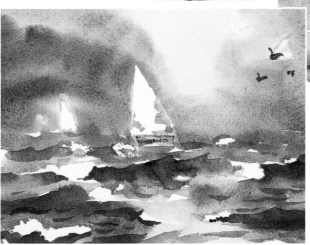

2 Soft, blurred highlights such as those in the background here are achieved by removing the paper before the paint is fully dry. These make a nice contrast with the sharp edges on the sail of the main boat and the sea.

3 The slightly random nature of the highlights gives the painting an attractive impression of movement.

ARTIST'S TIP
One of the commonest uses of masking fluid is for painting flower-strewn meadows. In this example, the fluid has been removed and the artist has begun to paint some of the flowers in red.

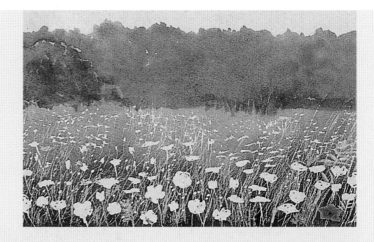

Analysis **Masking fluid**

John Lidzey Figure in a Cornfield

John Lidzey enjoys experimenting with different techniques and combinations of media, and this painting shows a very inventive use of masking fluid, which he has used to create a broad impression of the flowers and grasses. Washes were laid on top of the fluid, which was then removed to leave white shapes. These were modified with further pale washes and touches of darker definition. An alternative method is to lay the fluid over an initial pale wash, but there can be a danger that removing the fluid will take off some of the paint.

Grasses defined mainly by the small shapes at the top of each clump, with the rest left mainly to the imagination.

Area left pale and largely undefined in order to help highlight the figure.

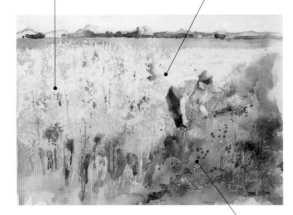

Dark paint dropped into still-wet color to balance the dark tones on the figure.

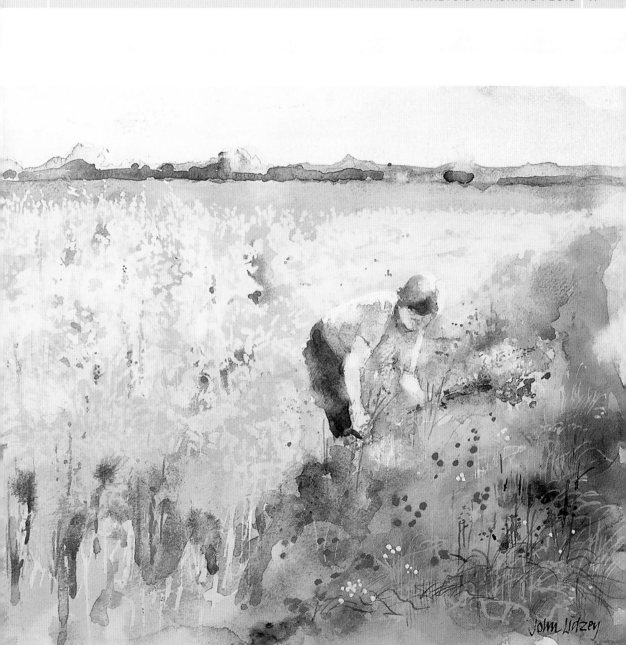

John Lidzey

Soft and scratched highlights

Soft or diffused highlights are somewhat different to those that can be achieved with masking fluid or the classic method of painting around shapes. But they are considerably easier to achieve, because they don't have to be planned in advance. If you view a painting in the final stages and decide that it needs lighter areas here and there, you can simply lift out dry paint by working into it with a damp brush or cotton bud. This is also a good way of reclaiming or sharpening up lost highlights.

You can also make highlight areas in the course of the painting by lifting out color before it has dried. In a flower study, for example, you could lay a wash for one or two flower heads or stems and "draw" into the paint with the point of a damp brush to make lines of highlight.

Using an eraser

Once your painting is completely dry, you can emphasize highlights by rubbing over them gently with a typewriter eraser or plastic eraser, sharpened to a point to increase accuracy. This removes some of the top layers of paint much in the same way as lifting-out methods.

Wiped highlights

While a wash is still wet, use a piece of cotton rag to wipe out linear highlights. If the wash has dried, damp the tissue or use a dampened cotton swab. This technique is particularly effective for light clouds or shafts of sunlight.

Scratched highlights

A well-known watercolor technique for small linear highlights, such as points of light on blades of grass in the foreground of a landscape, is to scratch them out with the point of a sharp knife. The paint must be completely dry before you do this, and the method must be reserved for the final stages of the painting, as it will scuff the paper and make it impossible to lay smooth colors on top.

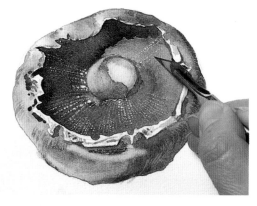

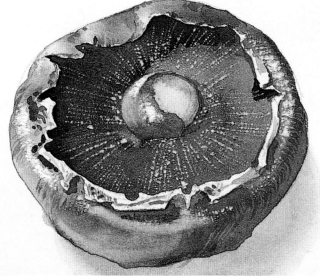

1 Build the painting up to the final stages and then scratch into the dry paint.

2 The fine lines are unlike anything that can be achieved by masking or reserving methods.

ARTIST'S TIP
Artists evolve their own techniques, and here a rounded palette knife is used to scrape into the paint to create the pattern of roof tiles—an unusual, but very effective, method.

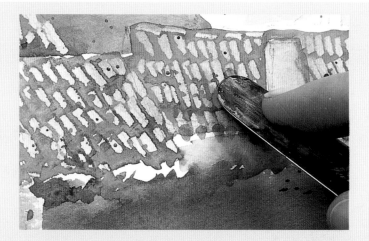

Lifting out

Removing paint is not only a correction method, it is a watercolor technique in its own right and can be used to great effect to soften edges, diffuse and modify color, and create those highlights that cannot be reserved. For instance, the effect of streaked wind clouds in a blue sky is quickly and easily created by laying a blue wash and wiping a dry sponge, paintbrush or paper tissue across it while it is still wet. The white tops of cumulus clouds can be suggested by dabbing the wet paint with a sponge or blotting paper.

Paint can also be lifted out when dry by using a dampened sponge or other such tool, but the success of the method depends on the color to be lifted. Some colors act rather like dyes, staining the paper, while others, such as the "earth colors," lift out very easily. Large areas of dry paint can be lifted with a dampened sponge, but for smaller ones the most useful tool is a cotton swab, using gentle pressure to prevent the stick poking through and scratching the surface of the paper.

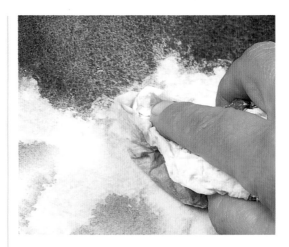

1 First a loose, uneven wash is laid down for the sky. While the paint is still wet, cloud shapes are lifted out by pressing with kitchen paper.

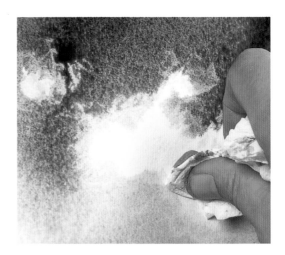

2 By varying the pressure applied, different amounts of color can be removed. The paper can also be rolled to a point to lift out fine details, as shown here.

3 A pale wash is applied for the sea. A piece of paper towel is then dragged across the damp wash to create varying bands of tone and color. The paint is left to dry.

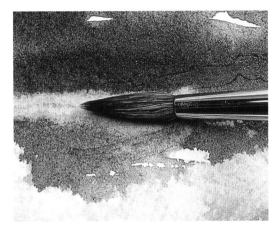

4 A clean, dry brush is used to lift out color in the middle distance to suggest a flat area between the hills.

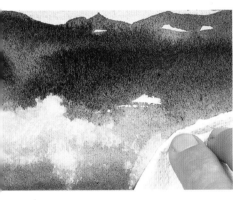

5 The distant headlands are painted in a gray-blue wash and the hills in the foreground in a deep green. A paper towel is again used to blot some of the color in the foreground to suggest forms in the landscape.

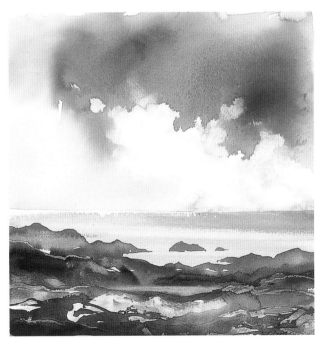

6 Although the palette has been restricted to somber blues and greens, the finished piece has considerable drama and the sky is completely convincing.

Wet-on-dry

Laying new (and therefore wet) washes over earlier ones that have been allowed to dry is the classic method of building up a watercolor. Since it is difficult to achieve great depth of color with a preliminary wash, the darker and richer areas of a painting are achieved by overlaying colors in successive layers.

One of the more irritating aspects of watercolor work is that of having to wait, sometimes for long periods, for paint to dry before the next color is added. It is perfectly permissible to use a hairdryer to hasten the process, but avoid using it on really wet paint, because you can find you are blowing a carefully placed wash all over the paper. It is equally permissible, of course, to paint some parts of a picture wet-on-dry and others wet-in-wet: indeed the most exciting effects are achieved by combining the two methods. The danger with wet-on-dry is that you can allow too many layers to accumulate and muddy the colors, so if you are working mainly in flat washes, always try to make the first one really light.

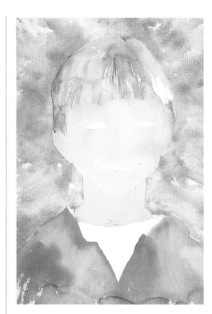

1 The artist lays down washes to establish the main areas of color on the head, clothing and background. These are left to dry completely before any further work is done.

2 She now begins to build up the tones to give form to the head and ears. Using a clean brush dipped into water, she lightly dampens the area to be worked into before applying the paint, which spreads slightly into the dampened area.

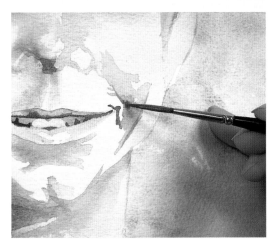

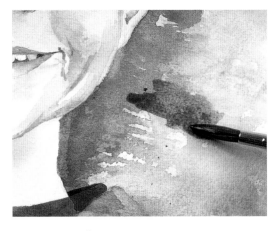

3 Using a fine, long-haired brush, she adds in detail. In places where crisp edges are required, she paints directly onto the dry wash.

4 She adds further washes to deepen the background tones where the background meets the lighter side of the face.

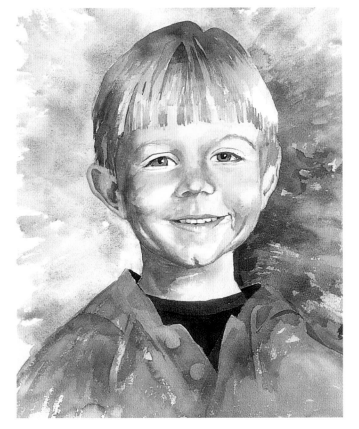

5 Note the careful contrasts between light and dark. The background is darkest where it meets the lightest parts of the face, but lightest against shadowed areas. These contrasts in tone serve to bring it forward in space and make it appear solid and three-dimensional.

Wet-in-wet

This means exactly what its name implies—applying each new color without waiting for earlier ones to dry, so that they run together with no hard edges or sharp transitions. This is a technique that is only partially controllable, but it is a very enjoyable and challenging one for precisely this reason.

For all-over wet-in-wet effects such as the first washes in a landscape, the paper must first be well dampened and must not be allowed to dry completely at any time. However, you can paint wet-in-wet for smaller areas either by dampening the paper selectively or by dropping a new wet color into a first one that has not been allowed to dry fully. Judging the precise wetness of the paper or underlying color is vital to the method, and is a skill that you will learn with practice. Paradoxically, when all the colors are very wet, they will not actually mix, although they will bleed into one another, but on slightly damp paper they will mix to a greater degree.

1 The artist has decided to rely on the wetness of the paint itself, rather than dampening the paper. She starts in the middle of the painting, dropping in very wet washes in a fairly random way and allowing the colors to bleed into each other.

2 The crisp edges of the flowers begin to form where each wash spreads out and then begins to dry.

3 She now turns to the foliage, using the same technique. She leaves the paint to mix and blend naturally—without interfering with the flow.

4 While the paint dries, she watches to see what forms have appeared and, where necessary, drops in a little more color into patches of still-damp paint. She can then begin the final stage of adding in fine lines and other details where needed.

5 The exuberant mass of flowers is perfectly offset by the barely worked form of the straight-sided vase, which has largely been left white.

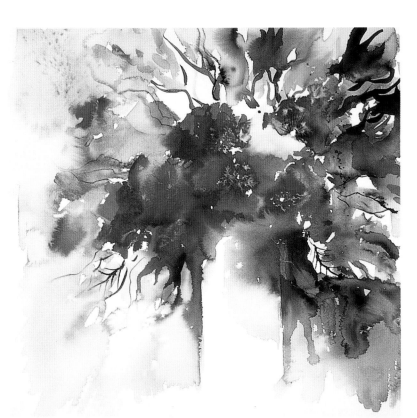

Analysis **Wet-in-wet**

Trevor Chamberlain The Flower Seller, Bow Church

This is an excellent example of the skillful use of the wet-in-wet technique combined with touches of crisper detail, and it also provides a lesson on the importance of light in landscape and architectural subjects. The artist has clearly been excited by the strong shapes of the church portico, offset by the figure and her pots of flowers, but the painting is really about the quality of light, expressed by the soft mingling of colors and the muted palette. All the colors, even the reds on the pillar box and flowers, are deliberately muted to create a gentle and harmonious atmosphere. In strong sunlight, the colors would be much brighter and the tonal contrast stronger.

Details of brickwork painted wet-on-dry, but tones kept light to preserve overall slightly blurred effect.

Soft patches of sunlight achieved by gently lifting out from damp color.

Paper allowed to dry before darker wash on right of light wall painted.

Wetness of paper carefully judged so that colors dry with soft edges but don't spread out too far.

J.Chamberlain '86

Hard and soft edges

A wet watercolor wash laid on dry paper forms a shallow pool of color that, if left undisturbed, will form hard edges as it dries, rather like a tidemark. This can be very effective, and is one of the characteristics of the medium that can be used to great advantage. By laying smaller, loose washes over previous dry ones, you can build up a fascinating network of fluid, broken lines that not only help to define form but give a sparkling quality to the work. This is an excellent method for building up irregular, natural forms such as clouds, rocks or ripples on water.

However, you will not necessarily want hard edges in every part of the painting. A combination of hard and soft edges describes the subject more successfully and gives more variety. In a flower painting or still life, for example, you might use soft effects in the background by working wet-in-wet (see page 54), and soften some of the edges on objects to show how they turn away from the light.

There are several other ways of avoiding hard edges. A wash on dry paper can be softened and drawn out at the edges by using a sponge, paintbrush or cotton swab dipped in clean water to remove the excess paint. A wash "dragged" or "pulled" over dry paper with either a brush or sponge will also dry without hard edges, since the paint is prevented from forming a pool. For the edges of small areas, such as petals or leaves, you can simply go over the edges with a clean, damp brush either before or after it has dried.

1 The artist lays a pale wash of cobalt blue to the sky, and a wash of the same blue mixed with yellow to the middle ground. She works wet-on-dry, taking care to paint around the outlines of the cows. While the sky is still damp, she works wet-in-wet, applying a wash of indigo and sepia down to the horizon line and allowing the colors to bleed together naturally.

2 She paints in the foreground using a stronger green and leaving some white highlights. She paints in the shadows on the cows, the fence rail posts and grass with a wash of indigo and sepia—working wet-on-dry so that hard edges form.

3 She then returns to the background and paints in the trees with a mix of cobalt blue and burnt sienna. Where these dark shapes meet the cow's silhouette, they reinforce the hard, crisp edge. She dabs the sky with a damp sponge to soften the outline of the clouds.

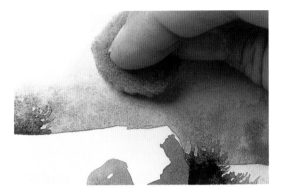

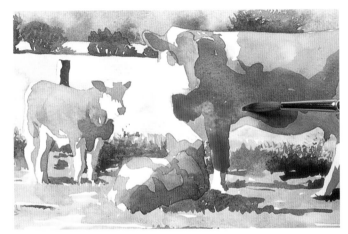

4 The painting is left to dry, and a second wash of strong, burnt sienna is laid on the bodies of the cows and calves, leaving areas of the first gray-brown wash showing.

5 The wet-in-wet work in the background gives an out-of-focus effect that places it firmly in the distance, while the crisp edges on the cows and grass bring the whole foreground area forward in the frame.

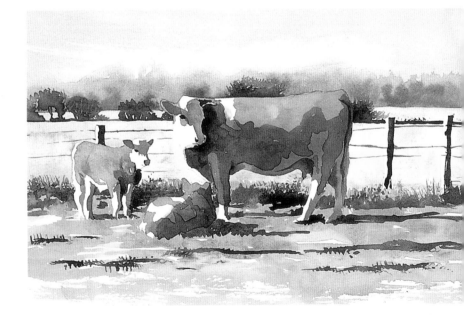

Underdrawing

For anything but very rapid sketches, it is important to make a pencil underdrawing before painting; this is a way of planning the composition as well as making sure that the shapes and proportions are correct. If you use a fairly hard pencil, such as HB or B, and keep the lines light, the paint will cover them. Some artists like to incorporate the drawn lines into the composition, and make a heavier, more positive drawing. Whichever approach you take, draw outlines only, avoiding any shading. If you need to erase the drawing, make sure that you brush off any small bits of eraser left on the surface, otherwise the paint will pick these bits up.

Guidelines for painting

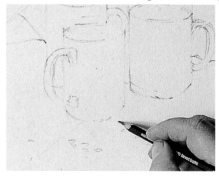

1 The artist is using a sharp but soft pencil (4B) for the drawing. Soft pencils are easier to erase than harder ones such as HB, but the choice is largely a personal one.

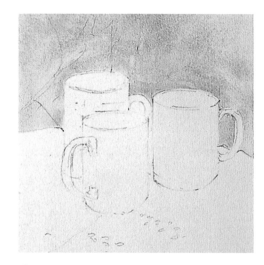

2 Here you can see the importance of the drawing. In a subject like this it is essential to take the background wash accurately around the shapes.

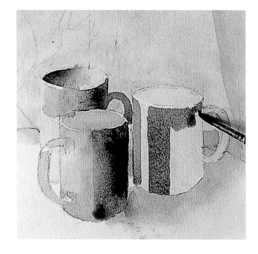

3 Again, the outline drawing helps the artist to place the bands of dark and light color that define the form of the mugs.

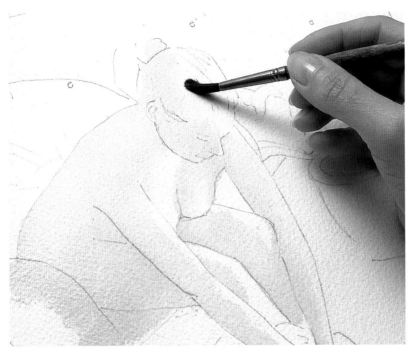

Painting the figure

It is essential to make a good underdrawing for anything as complex as a figure or portrait. Here the artist follows her drawn guidelines, which help her to decide where to leave the highlights in the basic skin tone.

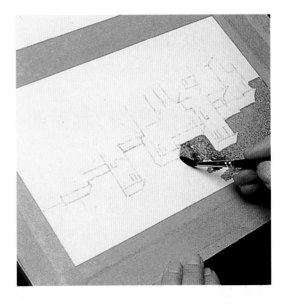

Working around edges

In this painting of buildings, the sky wash is laid with the board upside down to make it easier to follow the drawn lines accurately. Even with a careful drawing there is a danger of paint slopping over the edges.

Altering and erasing

Watercolor painting can be a nerve-racking business, as things often go wrong. But you seldom need to throw the paper away and start again if a wash dries blotchy or if you find you have slopped paint over an edge that was meant to be white. There are many ways of making corrections, and if you are dissatisfied with a finished picture, why not put the brushes down and draw on top of the paint with colored pencil or pastel?

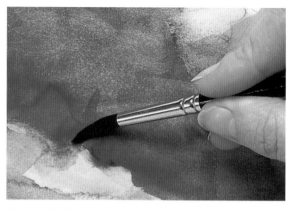

Brushing out

If you think that the edge of a brushstroke is too hard or soft, and you want to achieve smooth edges, "tickle" them out with the tip of a slightly damp brush.

Removing paint

Trying to move watercolor once it has dried can be difficult, but it is possible. Once your watercolor has dried, it can still be re-wet, moved around or partially removed from the paper. A sponge may work better than a brush for this purpose. Bear in mind, however, that some colors cannot be completely removed because the pigment in the paint will have stained fibers in the paper.

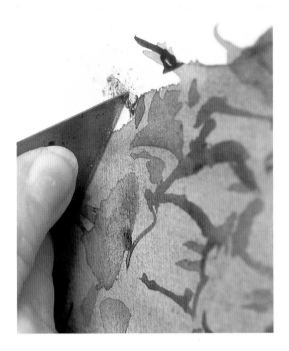

Scraping off

Small blots and blemishes are easily removed by scraping with a knife or razor blade. This must be done with care, however, or the blade might tear holes in the paper.

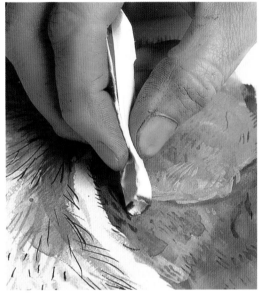

Blotting off

If one color floods into another to create an unwanted effect, the excess can be mopped up with a small sponge or piece of blotting paper.

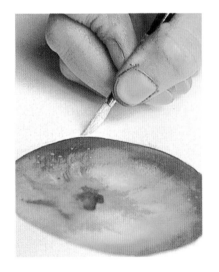

Overpainting with white

Ragged edges can be tidied up by painting around them with white gouache paint. This is also a good way of reclaiming lost highlights.

Backruns

These are among the accidental effects in watercolor work that can be a disaster, but they can also be encouraged and used to advantage. Unwanted backruns are usually the result of trying to work into a wash before the paint has dried. If there is more water in the new paint, the semi-dry color will "run away" from it, causing blotches or cauliflower shapes. These can suggest forms, and are often deliberately induced to suggest clouds, foliage or flowers, or simply employed to enliven an undefined area of background.

Color into color

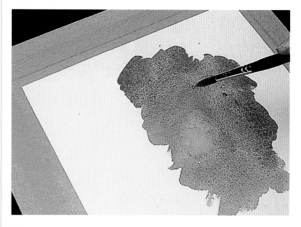

1 The effect of backruns depends on the water content of the paint. In this instance, the red and the blue are about the same strength, so they have run into one another without creating a backrun. However, the yellow has more water in it, so the paint has begun to flow outward.

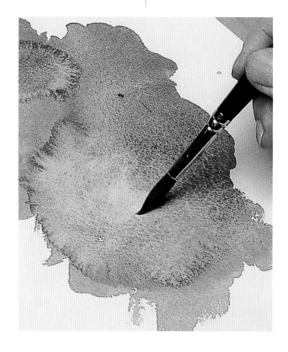

2 A little watery paint has been dropped into the blue at the top, and more yellow has been added in the center, causing backruns to form. The paint will continue to move until dry.

Water into color

1 You can make dramatic backruns by simply dropping clean water onto wet paint; the more water the larger the backrun.

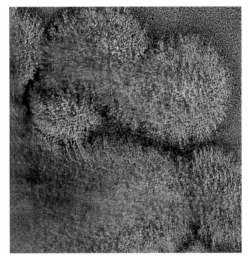

2 This cluster of backruns is exciting in itself, but the method can be used descriptively—for foliage or flower heads, for example.

ARTIST'S TIP
Deliberate backruns are a good way of achieving irregular highlights, such as those created by the sun lighting up clumps of foliage. The paint does not have to be wet; you can drop a light, wet color into a darker, dry one, or touch in a little water with the tip of the brush.

Continued on next page

Exploiting backruns

1 In this painting, the artist aims to exploit the natural backruns formed by watercolor to suggest the loose, organic shapes of flowers. She begins in the center of the painting, applying patches of very wet wash and allowing the paint to spread and settle naturally. When the paint is partially dry, she floats in other colors on top. Notice the "eyes" of unpainted white paper left in the center of each flower.

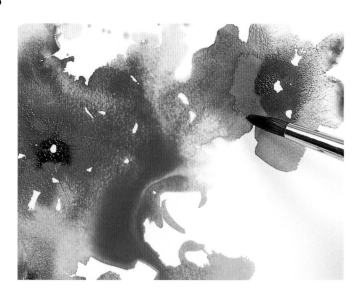

2 While the paint is drying, the artist works on other parts of the picture. Here, she adds another flower form, applying a rich blue over a patch of damp red.

3 By paying careful attention to the relative dryness of different areas, various effects can be achieved. Here blue has bled into damp yellow to form a patch of green. While the green is still damp, the artist feeds in red on top.

4 Different drying times of the various washes can lead to such happy accidents as this green "cauliflower" leaching into the underlying yellow wash. Such pleasing organic shapes, which form the basis of the painting, can then be given definition with deliberately added detail, such as the finely veined leaf seen here.

5 Yellow washes loosely applied and allowed to settle in their own way form distinctive though abstract shapes at the bottom of the painting.

6 Although the subject matter is clearly recognizable, the picture still retains a pleasing looseness and spontaneity— the trick here is to know when to stop so as not to ruin the effect by overworking the painting.

Brush drawing

Drawing freely and directly with a brush is an excellent way to loosen up your technique. Artists over the centuries have made brush sketches, sometimes using pen marks as well—the Chinese and Japanese made the technique into a fine art. Light pressure with the tip of a medium-sized, pointed brush will give precise, delicate lines. A little more pressure and the line will become thicker, so that it is possible to draw a line that is dark and thick in places and very fine in others. More pressure still, bringing the thick part of the brush into contact with the paper, will give a shaped brush mark rather than a line. Thus, by using only one brush you can create a variety of effects; and, if you use several brushes, including broad, flat-ended ones, your repertoire will be almost endless.

The technique can be combined with others in a painting and is particularly useful for conveying a sense of movement, in figures, animals or even landscape.

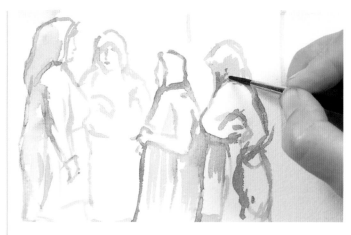

1 Using a relatively fine brush and a pale color, the artist draws in the main outlines of the figure and the background, and indicates some of the main tonal areas.

2 She begins to build up the painting use a medium round brush and washes of deeper color.

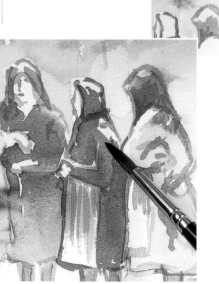

3 She works on the group of women, paying attention to the tonal contrasts that give definition to the individual figures.

4 With the small brush and a dark color, she draws in the fine detail —the folds in the dresses, the shadows on the legs *(right)* and the apron strings on the figure on the far left *(below)*.

5 The completed painting shows a perfect balance between the detail on the figures and the lightly sketched buildings, which are conveyed with no more than a few fine lines and light touches of tone. The foliage overhanging the wall reinforces the composition while the shadows along the ground anchor the group of figures.

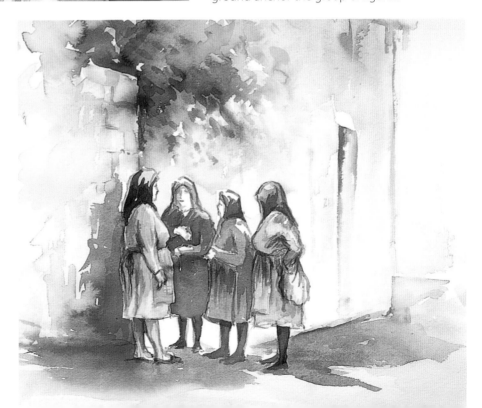

Analysis **Brush drawing**

David Boys is a professional wildlife artist who needs to be able to work very fast in order to capture the essence of his moving subjects. In these sketchbook studies, on which he bases his finished paintings, he used his brushes very much like drawing implements to suggest textures and details. Notice how the brushmarks follow the directions of the feathers, and how they vary in size from long to short.

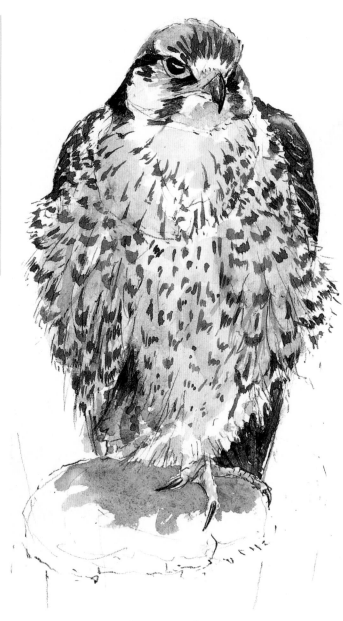

Small washes were laid as a base color and worked over wet-on-dry with the point of a round brush.

Short, squiggling brushmarks were used to describe the patterns on the long feathers, and dots and dashes for the shorter breast feathers.

Capturing texture

The artist has caught the hunched pose of the bird and its rather brooding gaze as well as the textures and shapes of the feathers. The carefully placed highlights on the eyes and beak both describe the forms and bring the bird to life.

Creating a context

In this painting, the artist has placed the birds in context by lightly suggesting foliage at the back and side of the picture, and has anchored them to the ground by means of cast shadows.

Waiting for a moment when the birds turned their heads to one side has allowed the artist to exploit the lovely dark-on-light patterns.

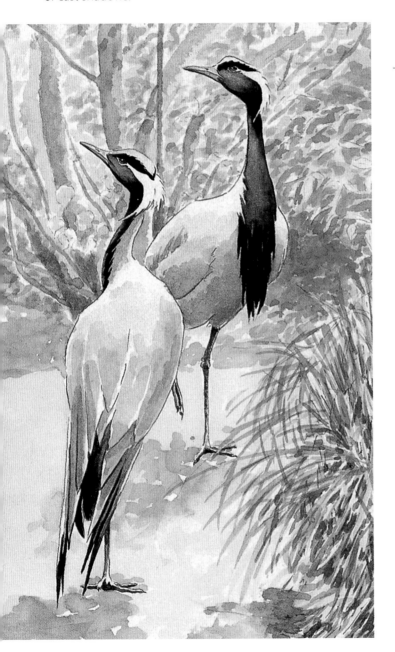

The placing of the feet is vital, as it explains the distribution of weight.

Drawing with a stick

A sharpened stick, twig or even the end of a paintbrush handle can be used to draw with paint, giving a more sensitive and unusual line than a standard pen. The usual method is to "pull out" paint from a wet wash rather than dipping the stick into an ink or a paint mixture, but you can also use it to make indentations in the paper—into which the paint flows to create strong lines. In both cases it is essential to work-wet-in-wet (see page 54), as there must be sufficient paint on the paper to facilitate this kind of manipulation.

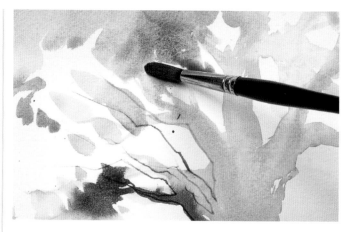

1 The artist begins by painting the trunk and main branches and then starts to build up the foliage with wet washes. She pulls out the dark brown paint to create some small, fine branches growing out from the trunk.

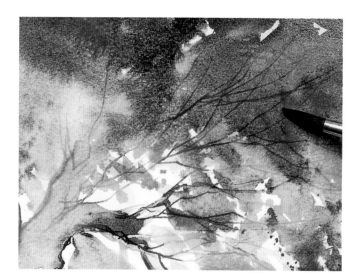

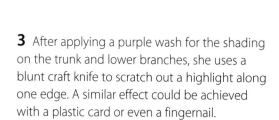

2 More washes are laid, with colors dropped in randomly so that they bleed into one another, and the twig is used again to indent the paper, building up the tracery of fine lines.

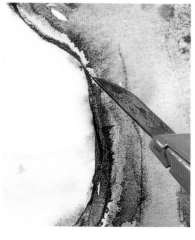

3 After applying a purple wash for the shading on the trunk and lower branches, she uses a blunt craft knife to scratch out a highlight along one edge. A similar effect could be achieved with a plastic card or even a fingernail.

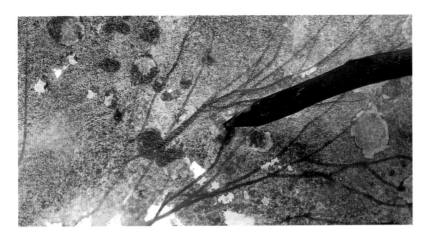

4 She now dips the twig into methylated spirits and flicks it onto the paper. This creates blobs of dark color with lighter edges, breaking up the color and giving a suggestion of the foliage.

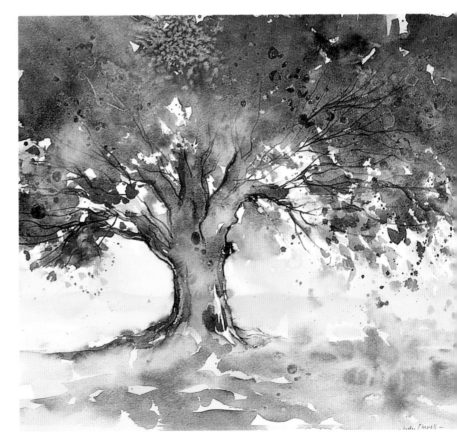

5 The finished painting gives a lively impression, with the sharply etched lines on the trunk and branches contrasting with the soft wet-in-wet painting of the foliage.

Dry brush

This technique is just what its name implies—painting with the bare minimum of paint on the brush so that the color only partially covers the paper. It is one of the commonest methods of creating texture and broken color in watercolor—particularly for foliage and grass in a landscape, or hair and fur textures in a portrait or animal painting. It needs practice: if there is too little paint, it will not cover the paper at all, but too much will simply create a rather blotchy wash.

Several layers of dry brush work can be laid over one another, either in the same or contrasting colors, and the direction of the strokes can be varied to build up a complex network of fine lines. Dry brush is a seductive technique, but as a general principle, it should not be used all over a painting, since this can look monotonous. Texture-making methods work best in combination with others, such as flat or broken washes.

1 Having pressed out excess moisture from the brush, the artist drags gray-blue paint across the paper for the sea. Since the paint is fairly dry, it does not spread evenly over the paper like a fluid wash, but produces a patchy finish suggestive of sparkling water.

2 While this is drying, she adds washes for the sky and an uneven wash of light ocher for the beach.

3 When the sea is completely dry, she dry-brushes streaks of indigo mixed with cerulean blue over it. She also paints in the headland, overlaying a wash of gray-blue on top of the semi-dry sky so that the two blend a little to create a softer effect.

4 The marram grass is painted in two layers, beginning with ocher and then darker olive greens. A small figure is added on the right, partially hidden by the grass.

5 The picture is completed with the addition of a little white gouache for extra highlights on the sea. Highlights are also scratched into the grass with a craft knife, and—as a final touch—the small figure of a dog running along the sand is placed in the middle ground.

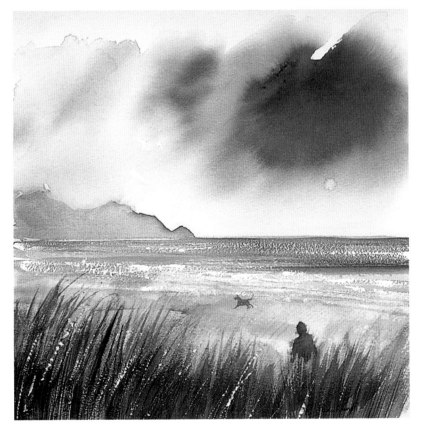

Analysis **Dry brush**

Charles Knight
Tall Tree and Buildings

Charles Knight's atmospheric landscapes are marked by
the economy with which he describes his shapes, forms
and textures. He never uses two brushstrokes when one
will suffice. Here he has painted freely but decisively in
a combination of wet-in-wet, wet-on-dry and dry brush,
leaving little specks of the paper showing through the
paint in places to hint at texture. The dry-brush work is
most evident in the foliage on the left of the picture, but
is has also been used to hint at trees in the background.
Notice how he has given warmth to the color scheme by
starting with a pale pink wash rather than working on
white paper.

*Diagonal dry-
brushed strokes help
to create a sense of
movement, leading
the eye toward the
tall tree that forms
the focal point.*

*Curving strokes at the
edge of the foliage
clumps define
the forms in an
economical manner.*

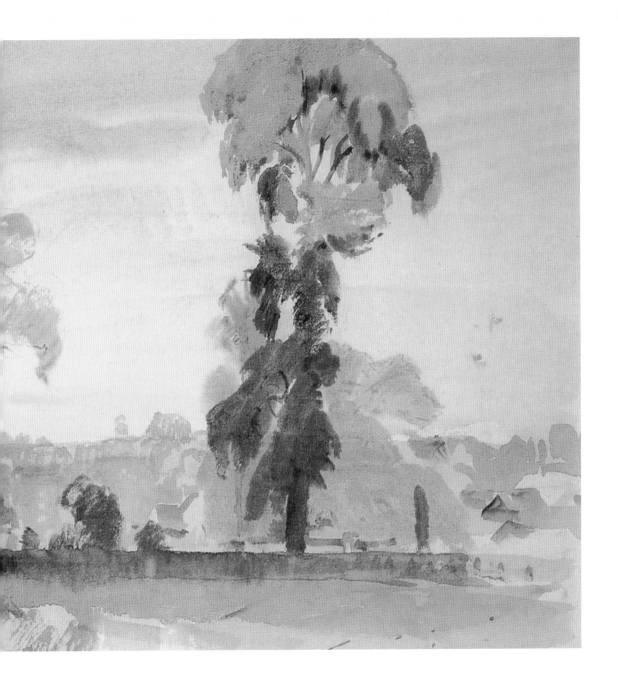

Glazing

This method, which is common to all the painting media, involves painting a layer of transparent paint over an already existing color or colors, which must be fully dry. In watercolor, most overlaid washes can be described as glazes, but this is slightly misleading, as successful glazing can only be done with the more transparent pigments, the idea being to modify an earlier color without obscuring it. Yellow ocher, for example, is relatively opaque, and thus does not work as a glaze, whereas lemon yellow is more transparent, as are many of the reds and blues (with the exception of cerulean blue).

Glazing is often applied to strengthen and add color to shadows, and can also be a useful way of changing a color by mixing on the paper surface. Yellow glazed over blue, for example, will produce green; and blue glazed over crimson will make purple.

1 The drawing is made in waterproof ink, which won't run when wet paint is applied, and the artist then lays a yellow wash, masking out a few white highlights.

2 The wash is allowed to dry, and glazes of blue are laid over the yellow for the background and shadow areas. Some of the masking fluid is removed at this stage.

3 Additional colors are built up in the same way, always using transparent colors, and final details are added to the vegetables and their immediate surroundings.

4 The effectiveness of the method derives from the way each color shows through the one before, giving a more lively effect than areas of flat color.

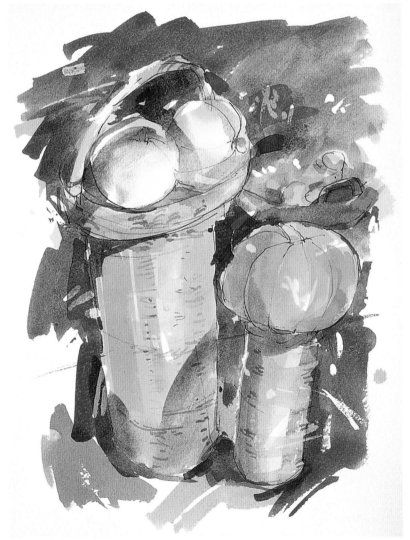

Gum arabic

This medium, together with gelatine, acts as the binder for watercolor pigment. Gum arabic is sold in bottled form for use as a painting medium. If you add a little to your water when mixing paint, it gives it extra body, making it less runny and easier to blend. It is particularly suited to painting which is built up in small, separate brushstrokes, since it prevents them from flowing into one another.

It is also very useful for lifting out (see page 50). If you paint a wash mixed with a little gum arabic over a dry base color and allow this to dry, you can lift out the second color very easily with a damp brush, as the water dissolves the gum. Interesting effects can be created in this way, for example you might paint a strong yellow wash for a tree, overlay it with green and lift out highlights. The second layer of color will come off much more cleanly than paint mixed with water alone, revealing the brilliance of the underlying color.

Gum arabic can also be used as a varnish for an area of a painting that has gone dead, but it should never be used alone, as this could cause cracking. Experience will teach you how much to dilute it when using it as a painting medium, but a general rule is that there should be a lot more water than gum (it is sometimes referred to as gum water for this very reason).

1 The paper is first covered with a pale wash of blue-green. When dry, liquid frisket (masking fluid) is used to mask out the shapes of the goldfish.

2 A wash of green and blue mixed with gum arabic is painted over the whole surface. While this is still damp, a clean, wet brush is pressed into the wash to lift out highlights in the water. Notice how cleanly this removes the color.

3 The masking fluid is removed, and darker washes and highlights are built up in the same way as before. Additional highlights are lifted out with a knife blade while the paint and gum mixture is still slightly damp.

4 To complete the picture, the goldfish are painted in tones of orange—contrasting vividly with the blue-greens of the water.

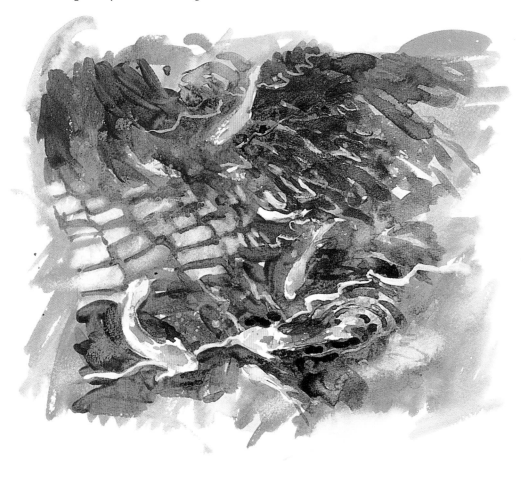

Body color

This slightly confusing term simply means opaque water-based paint. In the past, it was a name usually applied to Chinese white, which was mixed with watercolor or used on its own for highlights. Nowadays, it is more often used as an alternative term for opaque gouache or acrylic paint.

Some watercolor painters avoid the use of body color completely, priding themselves on achieving all the highlights in a painting by reserving areas of white paper. There are good reasons for this, because the lovely translucency of watercolor can be destroyed by the addition of body color, but opaque watercolor is an attractive medium when used sensitively.

Transparent watercolor mixed with Chinese white, gouache zinc (not flake) white, or titanium white acrylic is particularly well suited to creating subtle weather effects in landscapes, such as mist-shrouded hills. It gives a milky, translucent effect slightly different from that of opaque paints used on their own—gouache especially has a rather chalky quality.

A watercolor that has gone wrong—perhaps become overworked or too bright in one area—can often be saved by overlaying a semi-opaque wash, and untidy highlights can be cleaned up and strengthened in the same way.

1 A toned ground is laid over the entire surface with pale beige acrylic, and when this is dry the building, trees and foreground are painted wet-in-wet with ultramarine, Prussian blue, alizarin crimson and sap green watercolor. There is little form or definition at this stage of the painting.

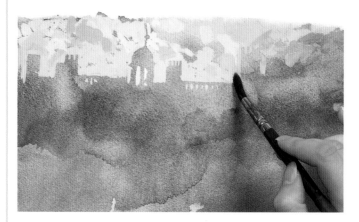

2 The first washes are allowed to dry, and yellow and gray gouache colors are used to build up the sky.

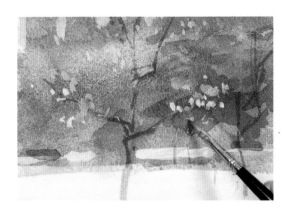

3 White, green and Indian yellow gouache are applied to the grassy area in the foreground, deliberately echoing the colors of the sky. Patches of especially solid body color here create the effect of dappled sunlight.

4 Further details, such as trunks and branches, are added to the trees, using olive green and Prussian blue watercolor. The artist then dabs on touches of pale yellow gouache to highlight some of the leaves on the foreground trees.

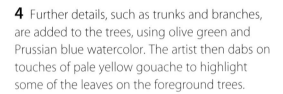

5 The mixture of misty, blue-mauve watercolor and sharp, solid gouache creates a highly atmospheric scene, suggesting the colors on a sunny early morning.

Analysis **Body color**

Martin Taylor Within the Castle Walls

Martin Taylor is especially interested in texture, and frequently combines watercolor with acrylic. In this painting he has built up the richly textured surface of the old stonework by successive scumbling with a dry watercolor and acrylic mixture over transparent washes. In places he has scuffed the paper with the blade of a knife, applied paint on top, and then repeated the process. Good watercolor paper is surprisingly tough and can withstand a good deal of such treatment. Taylor has an interesting working method. Rather than building up all the areas gradually at the same time, he starts at the top and works downward. This is not recommended for beginners, as it involves having a clear and accurate idea of the composition and all its component parts.

Shadows lightly glazed over acrylic and watercolor mixes with transparent watercolor.

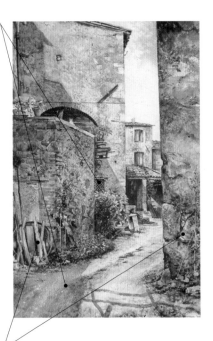

Touches of foreground detail add interest and enhance the atmosphere.

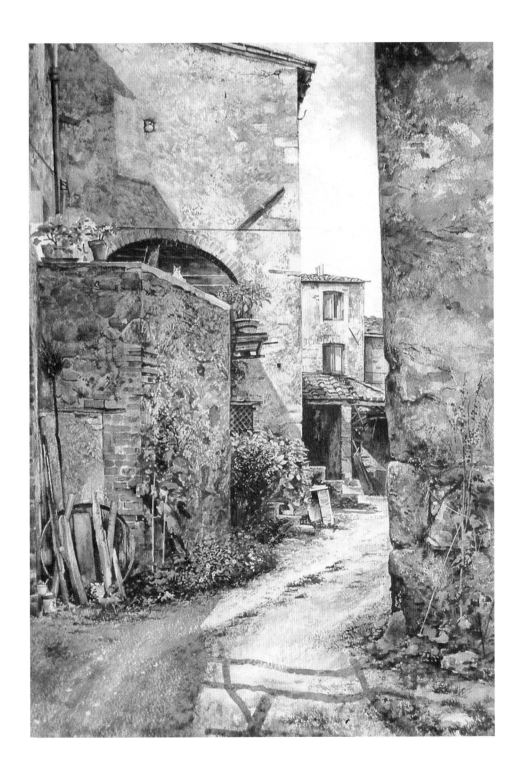

Spattering

Spraying or flicking paint onto the paper, once regarded as "tricksy" and unorthodox, is now accepted by most artists as an excellent means of enlivening an area of flat color or suggesting texture.

Spattering is a somewhat unpredictable method. It takes some practice before you can be sure of the effect it will create, so it is wise to try it out on some spare paper first. To make a fine spatter, load a toothbrush with fairly thick paint, hold it horizontally above the paper, bristle side down, and run your index finger over the bristles. For a coarser effect, use a bristle brush, loaded with paint of the same consistency, and tap it sharply with the handle of another brush.

The main problem with the method is judging the tone and depth of color of the spattered paint against that of the color beneath. If you apply dark paint—and thick watercolor will of necessity be quite dark—over a very pale tint, it may be too obtrusive. The best effects are created when the tonal values are close together. If you are using the technique to suggest the texture of a pebbled or sandy beach, for which it is ideal, you may need to spatter one pale color over another. In this case, the best implement is a mouth diffuser of the kind sold for spraying fixative. The bristle-brush method can also be used for watery paint, but will give much larger drops.

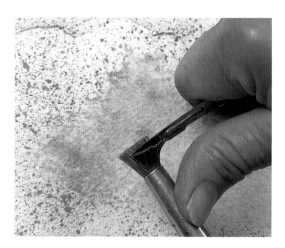

1 The sky is first masked out with a piece of torn paper—a torn, rather than cut, edge gives a more natural line. Low-tack tape can be used to hold the mask in place. The artist then begins spattering greens and yellows onto the paper by running a scalpel over the bristles of a blunt-ended stenciling brush.

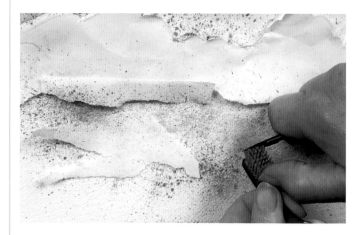

2 When the first application of paint is dry, she lays more torn paper masks over the surface and begins spattering red paint from a toothbrush. When the masks are lifted, they will leave spattered red edges suggestive of the drifts of poppies in the field. The artist continues building up the rest of the picture in the same way.

3 When all the paint is dry, she dabs in the larger poppy heads in the foreground with a fine brush. She also paints in the long grass, the tree trunks, the rooftops and the sky, and adds in shadow where necessary.

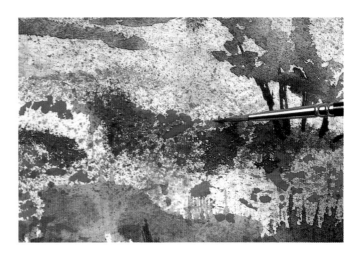

4 Although there are large areas of white in the finished landscape, the almost pointillist effect of the spattered paint suggests what is not there—and the eye "fills in" the rest.

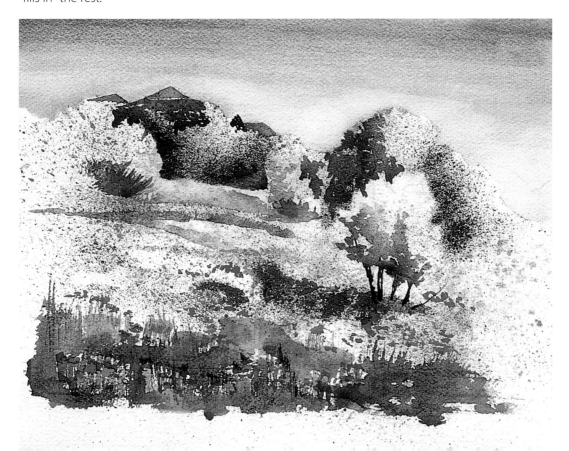

Salt spatter

This is one of the most exciting ways of creating texture and surface interest, or both. If you scatter crystals of rock salt into a wet wash, they will gradually absorb the paint, drawing it in to each crystal, to leave a lovely snowflake shape when dry. The effects vary according to how wet the paint is and how thickly or thinly the crystals are distributed, so you will need to experiment. It is a time-consuming method, because the salt takes some time to absorb all the paint, but the end result is worth the wait.

Salt spatter is often used to suggest specific textures such as those of pitted and barnacle-encrusted rocks on a seashore, old stone walls or areas of foliage —where you want suggestion rather than precise definition. The best way to find applications for the technique is to make a series of samples to see what they suggest.

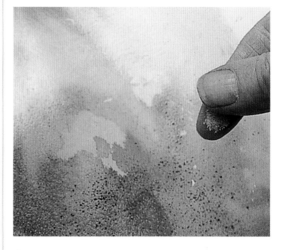

1 The artist has laid a variegated wash, working wet-in-wet, and now scatters salt into the still-wet paint.

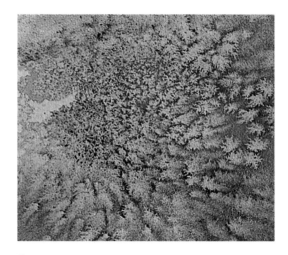

2 Many different effects can be achieved, depending on how much salt is put on. In this case a good deal has been used, and it has been spattered closely.

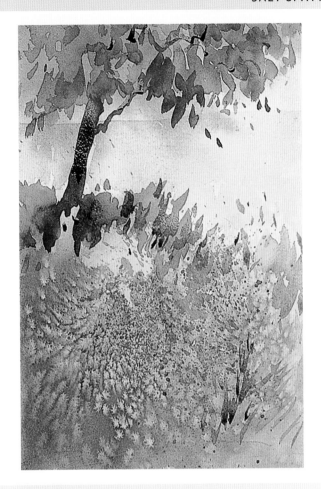

3 The spatter has been cleverly integrated into the landscape so that it creates an exciting sense of movement and suggests texture without being literally descriptive.

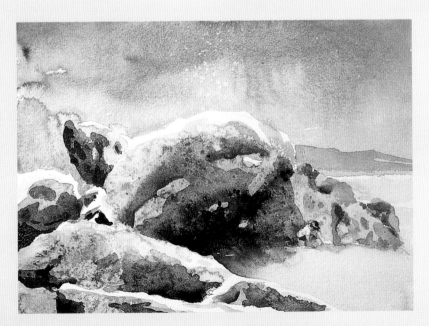

ARTIST'S TIP
In this attractive painting, several layers of salt spatter have been used to give an accurate impression of the crumbly texture of the seashore rocks. To give unity to the painting, a little salt has also been spattered into the loose wash for the sky.

Sponge painting

Sponges are an essential part of the watercolor artist's toolkit. They are useful for mopping up unwanted paint, cleaning up edges and making corrections, but they can also be used in a more creative way for applying paint—either alone or in conjunction with brushes.

Laying a flat wash is just as easy with a sponge as it is with a brush (see page 30), though it cannot take a wash around an intricate edge in the same way that a brush can. If you intend to begin a painting with an overall wash of one color, a sponge is ideal, but its main use in painting is to create texture, as dabbing paint onto paper with a sponge gives an attractive mottled effect, especially if you use the paint reasonably thick. The method is often used for foliage, and allows you to suggest form as well as texture by applying the paint lightly in some areas and densely in others, or by laying on successive layers of color. There is no reason why whole paintings should not be worked using this method, but brushes are usually brought into play for the later stages—to create fine lines and details.

1 When paint is dabbed on with a sponge, it adheres to the raised parts of the paper. For this reason, the artist has deliberately chosen a rough paper to emphasize the effect. Using a sponge loaded with warm yellow paint, she is able to cover large areas quickly, dragging and wiping the color across the surface.

2 When the first coat of color is dry, she dabs on orange to begin defining the forms.

3 She now creates more precise areas of shadow using burnt sienna and applying it with a sponge pinched between her fingers to make more exact marks.

4 A brush is used to paint in the leaves and further shadows around the fruit and the dish.

5 The mottled finish that sponging creates is ideal for conveying the pitted surface of fruit such as oranges, and the method also gives an unusual feel to the painting.

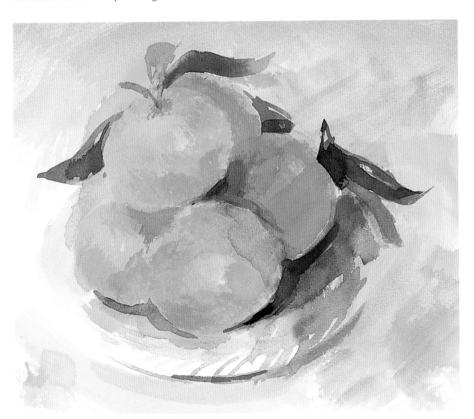

Stippling

This is a method of applying paint in a series of separate, small marks made with the point of the brush, so that the whole image consists of tiny dots of different colors. It was and still is a technique favored by painters of miniatures, and is seldom used for large paintings for obvious reasons. However, for anyone who enjoys small-scale work and the challenge of a slow and deliberate approach, it is an attractive method and can produce lovely results quite unlike those of any other watercolor technique.

The success of stippled paintings relies on the separateness of each dot: the colors and tones should blend together in the viewer's eye rather than physically on the paper. Like all watercolors, they are built up from light to dark, with highlights left white or only lightly covered so that the white ground shows through, while dark areas are built up gradually with increasingly dense brushmarks.The beauty of the technique is that it allows you to use a variety of colors within one small area—a shadow could consist of a whole spectrum of deep blues, violets, greens and browns. As long as they are all close enough in tone, they will still "read" as one color, but a more ambiguous and evocative one than would be produced by a flat wash of dark green.

1 The main areas of color are established with flat washes, leaving the statuette white at this stage.

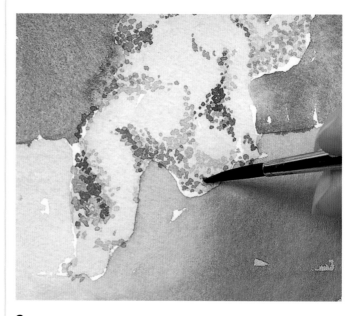

2 The artist then begins building up the shadows, stippling on tiny dots of blue and blue-gray around the outline of the statuette to define its shape.

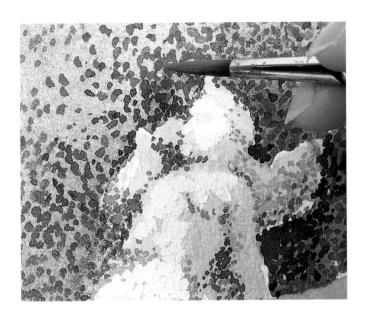

3 The same stippling technique is used on the background, with dots of various colors applied. Where the shadows need to be darkest, the dots are heavily worked to become almost a solid tone.

4 The dots of color mix in the eye—known as optical mixing—so that when viewed from a distance the eye reads them as single colors, but providing a more lively surface than flat color.

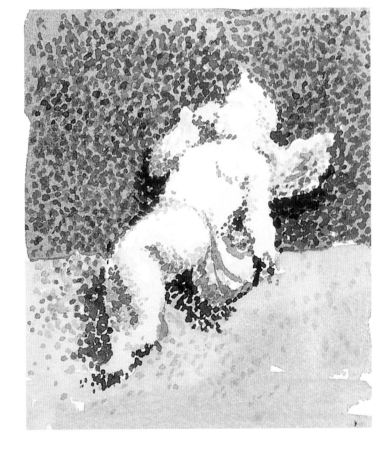

Scraping back

Sometimes called sgraffito, this simply means removing dry paint so that the white paper is revealed. The method is most often used to create the kind of small, fine highlights that cannot be reserved, such as the light catching blades of grass in the foreground of a landscape. It is a more satisfactory method than opaque white applied with a brush, because this tends to look clumsy and, if laid over a dark color, does not cover it very well.

Its use is not restricted to highlights, however, and it can be used as a technique in its own right. Scraping into damp paint with an implement like a plastic card removes some of the color and creates interesting edge qualities. Using a knife scuffs the paper so that any subsequent washes have a built-in element of texture. The technique is not successful unless you use a good-quality, reasonably heavy paper—it should be no lighter than 200 lb (see page 12), as light paper will not be able to stand such punishment.

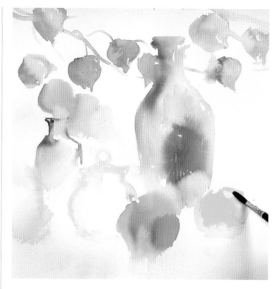

1 The painting is begun in the normal way, with preliminary washes to establish the shapes.

2 After adding more color, the artist uses a round-bladed craft knife to scrape out the plant stems while the paint is still slightly damp. Working in this way requires careful judgment. If the paint is too wet, the color will simply flow back into the space it previously filled, but if left to dry completely, it can be more difficult to scrape away.

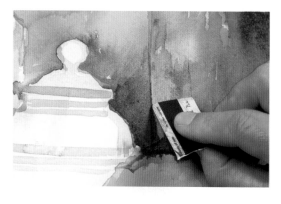

3 An old credit card provides a useful edge for scraping away just-damp color. Notice how this produces a lighter band of color.

4 A fingernail provides another ready tool for scraping back.

5 Final highlights to suggest shafts of light are achieved by rubbing into the dry surface with a piece of sandpaper folded to a knife-edge.

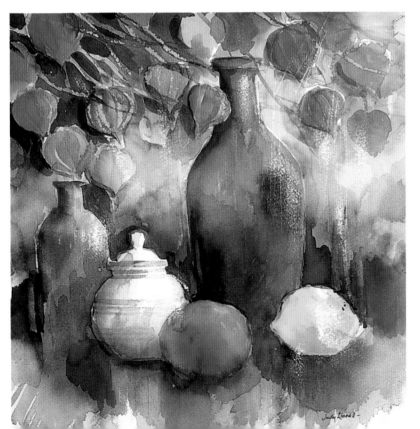

6 The combination of translucent washes and rough textures give the finished still life an attractive surface quality.

Impressing and indenting

Surface patterns can be made by pressing a variety of materials, such as rough-textured fabric, into wet paint. If the paint is left to dry or partially dry before removing the fabric, the imprint will remain in the paint. A version of this method is to lay plastic kitchen wrap over a wet wash. The film will crumple as you lay it, rather than going down flat, and when removed will leave a random pattern of irregular triangles, squares and broken lines. You can control the effect to some extent by crumpling the wrap in advance—for example, making a series of folds or pleats will give a linear pattern that could suggest tree trunks, or the stems of flowers in a vase.

Drawing into wet paint with a pointed implement is an allied method, useful when a painting calls for unobtrusive dark lines. Pressing into the damp paper makes indentations—small valleys into which the paint will flow, thus creating a line that is darker than the surrounding color. This method is often used for leaf veins or the linear pattern of tree bark.

Using plastic wrap

1 A wide variety of effects can be achieved with plastic wrap, depending on how you crumple or fold it and how long you leave it in place. Here, the artist makes small pleats in the wrap with his fingers before placing it on the paint.

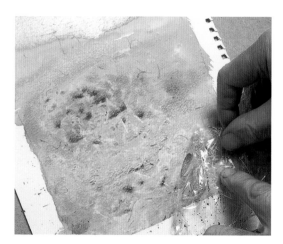

2 When the wrap is removed, you see a pattern of small, dark pools and lighter lines that could suggest a number of textures in the real world.

Using fabric

2 The fabric is removed leaving an interesting random texture that could suggest old, crumbling brick or stone.

1 Colors roughly suggesting a landscape are laid loosely onto the paper, and a heavy textured canvas is pressed into them while still wet.

Indenting

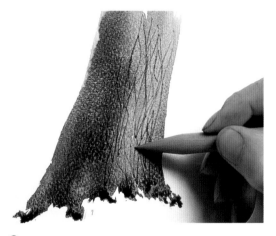

1 This method has obvious practical applications, and is very easy to do. For tree bark, first lay on the colors and make sure that they are right, because you won't be able to work over the indented area to any extent.

2 While the paint is still wet, draw into it with a pointed implement such as a knitting needle; avoid sharp points or you may damage the paper. You can use the indenting technique for linear details as well as texture, for example, small twigs or grasses.

Wax resist

This, a valuable addition to the watercolorist's repertoire, is a technique based on the antipathy of oil and water, and involves deliberately repelling paint from certain areas of the paper while allowing it to settle on others.

The idea is simple, but can yield magical results. If you draw over paper with wax and then overlay this with watercolor, the paint will slide off the waxed areas, giving an attractive mottled effect. You can use either an ordinary household candle or inexpensive wax crayons, and the wax underdrawing can be as simple or as complex as you like. You can suggest a hint of pattern on wallpaper or fabric by means of a few lines, dots or blobs made with a candle or make an intricate drawing using crayons.

Wax resist is one of the best methods for imitating natural textures such as those of rocks, cliffs or tree trunks, but like all tricks of the trade, should be reserved for certain areas of the painting only, since textured areas make more of an impact if they are juxtaposed with smooth.

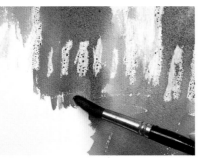

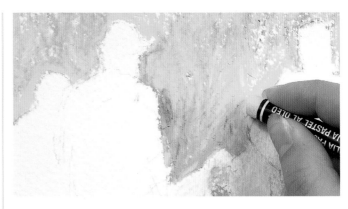

1 Having first lightly penciled in the outlines of the figures, the artist roughly scribbles over the sunlit background and trees using first a white wax candle and then green and yellow oil pastels.

2 Dark shades of watercolor are then flooded over the whole area. The waxy parts reject the watercolor, but where there are tiny gaps in the waxy surface, the color adheres, creating broken shapes and a speckled effect that is characteristic of the technique.

3 As this close-up shows, you can't achieve even surface coverage using a waxy medium, such as you would with masking fluid (see page 44), but this is the point of the method and the essence of its charm.

4 When the initial washes are dry, additional tones are added to define the forms without overworking them.

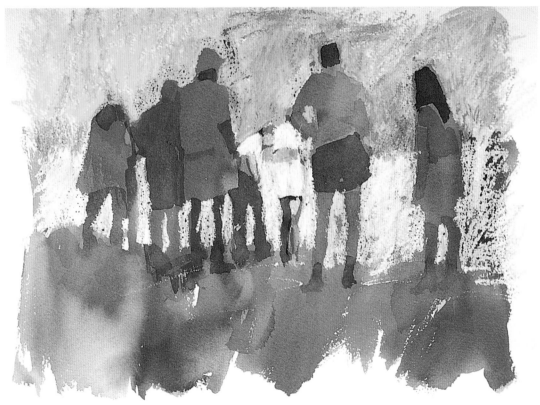

5 The finished piece shows just how effective the wax resist technique can be. The sunlit background and the shadowy forms in the foreground are suggested with just enough tone and detail in the lightest, most impressionistic way.

Line and wash

This technique has a long history and is still much used today, particularly for illustrative work. Before the 18th century, it had been used mainly to put pale, flat tints over pen drawings, a practice that itself continued the tradition of the pen and ink-wash drawings often made by artists as preliminary studies for paintings.

The line-and-wash technique is particularly well suited to small, delicate subjects such as plant drawings, but it can also be used in a bolder way for large-scale works, as many different thicknesses of pen can be incorporated. The traditional method is to begin with a pen drawing and then work in a fluid, light color with a brush. One of the difficulties of the technique is to integrate the drawing and the color in such a way that the washes do not look like a "coloring-in" exercise. It is, therefore, often more satisfactory to develop both line and wash at the same time, beginning with some lines and color—and then adding to and strengthening both as necessary. You can also start back to front, as it were, laying down the washes first to establish the main tones and then drawing on top, in which case you will need to begin with a light pencil sketch as a guideline.

1 To maintain the liveliness of the painting, the artist has chosen a variety of waterproof and water-soluble, fiber-tipped pens in different colors for the line work—rather than the more usual approach of drawing in a single color. Here, she draws in some of the outlines in green and others in red and or dark blue.

2 Loose patches of gray are laid over the boats and foreground, leaving plenty of white space to retain the freshness of the picture. Where the wash has been taken over the water-soluble pen lines, the ink dissolves and bleeds into the damp paper, creating pockets of intense color.

3 To complete the picture, slate-gray and pale crimson washes are applied to the cliffs in the background. When the paint in the foreground is dry, a few small details, such as the name on the boat on the left, are added with fiber-tipped pen. Notice how the color of the pens spread when washes are applied.

Analysis **Line and wash**

Edward Piper Melleiha, Malta

Edward Piper has integrated the line and color elements very cleverly in his painting (below). He has not attempted to outline areas of color with pen lines, but instead has placed the colors in an almost random way so that they sometimes overlap the lines and sometimes end well within them, as on the left side of the church. The painting has the lively feel that characterizes the artist's personal approach to the line and wash method. Notice the variety of different pen marks and how they vary in thickness.

Thick, curving lines give form and definition to the trees.

Kay Ohsten Buildings in Provence

In Kay Ohsten's sketch, made as a reference for a painting, the line has been used mainly to clarify certain aspects of the subject and to sharpen up shapes and forms. The line-and-wash technique can be very helpful if you want to record impressions quickly, as it takes much less time to sketch outlines of buildings, trees and so on with a pen than it does to build them up in paint.

Without the added line, this area would have been simply a meaningless area of tone, inadequate as reference.

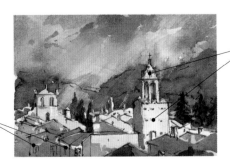

Line used to provide reference for architectural details.

Mixed media

Although many artists know that they can create their best effects with pure watercolor, more and more are breaking away from convention, finding that they can create livelier and more expressive paintings by combining the attributes of several different media.

To some extent, mixing media is a matter of trial and error, and there is now such a diversity of artist's materials that there is no way of prescribing techniques for each one or for each possible combination. However, it can be said that some mixtures are easier to manage than others. Pencil and watercolor is a commonly used combination, as is pen line and watercolor, as seen on the previous pages, and many artists draw over watercolors with colored pencils or pastels. The only way to explore the natures of the different materials, and find out the most effective means of using them, is to try out various combinations. You could use a failed watercolor as a basis—many successful mixed-media paintings are less the result of advance planning than of exploratory reworking.

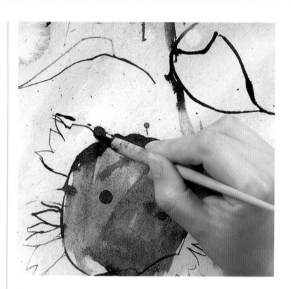

1 For this painting, the artist begins with blue acrylic ink, dripping it onto damp paper and rubbing it in with a paper towel to create a toned ground. She now uses an ink dropper to draw in some rough outlines, and then blocks in areas of darker tone with a paintbrush and ink mixed with gum arabic (see page 80).

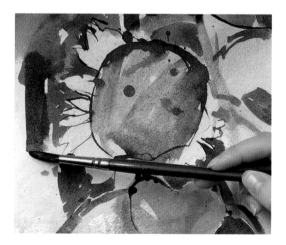

2 She continues to build up the tones, using a mixture of ink and gum arabic with some watercolor for the lighter areas.

3 She paints the sunflower petals in yellow gouache. Because opaque paint tend to come forward from thinner, more transparent color, this gives the flowers extra emphasis.

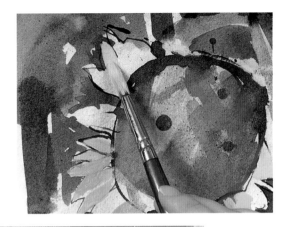

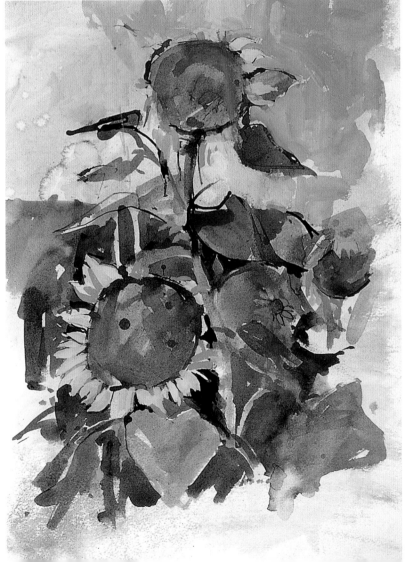

4 The finished picture shows how well the two media complement each other. The patchy, translucent, blue-green ink washes provide the perfect contrast to the strong, flat, yellow gouache of the flower petals.

Squaring up

It is not always necessary to begin a painting with a detailed drawing, but some subjects, such as portraits or architectural paintings, call for a careful, methodical approach in the early stages.

One way of avoiding too much drawing and erasing on the paper, which can spoil the surface, is to make a smaller study of the subject first and then transfer it to the watercolor paper by squaring it up to the size desired (you can use a photograph if preferred). This is a slightly laborious process, but it is not too difficult and really does pay off when the effect of the painting depends on accuracy.

Using a ruler, draw a measured grid over the study or photograph, then draw another grid on the watercolor paper, using light pencils marks. This must have the same number of squares, but if you want to enlarge the drawing, they must obviously be larger. If you use a 1-inch (2.5-cm) grid for your original drawing and a 1½-inch (3.8-cm) grid for the painting, it will be one-and-a-half times the size and so on. When the grid is complete, look carefully at the drawing, note where each line intersects a grid line, and then transfer the information from one to the other.

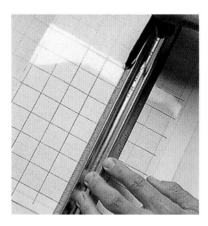

1 The method shown here avoids damaging the original drawing or photograph. A grid is drawn with a fiber-tipped pen on a sheet of acetate. The grid is traced from a sheet of graph paper beneath it, which saves time and is very accurate.

2 The next stage is drawing an enlarged version of the grid on the working paper. Pencil, T-square and ruler are needed for this, and the pencil lines of the transferred grid should be as faint as possible.

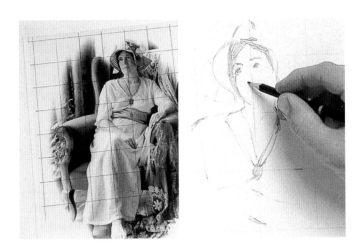

3 The acetate sheet is then placed over the photograph or sketch, and the image is transferred to the working paper square by square. This process should not be rushed and the work should be checked carefully as it progresses, or part of the composition could be placed in the wrong square.

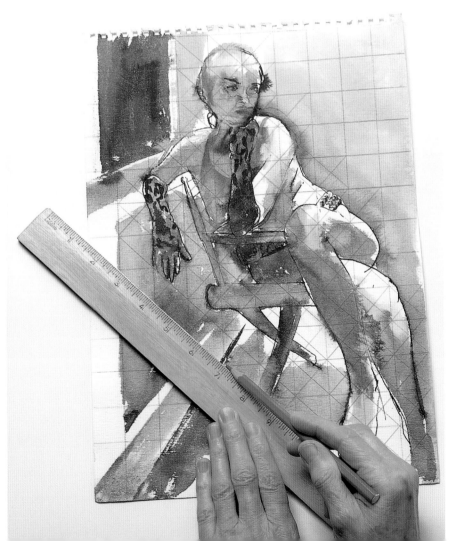

4 Dividing the square up diagonally into triangles breaks the original image up into even smaller segments, thus providing an even more exact grid to work from.

Managing your watercolors

Preserving paint

To prevent your watercolor pans from drying or cracking up, mix them with gum arabic. If you don't have any gum arabic, put a blob of honey or glycerin onto the dried out pan instead. Allow the glycerin or honey to soak into the paint before you start using it. This will make the paint more soluble, while retaining some of the moisture in its composition.

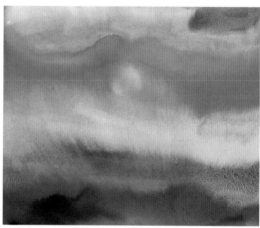

Working big

When you work on a large scale, try mixing watercolors in containers, rather than in your paintbox. This means you can paint quickly and smoothly without having to stop to mix more colors, and you will be able to store the fluid for following sessions, retaining the exact color mix required.

Faster drying

If you are working in damp weather and find that your watercolor is not drying quickly enough, use a hairdryer to accelerate the process. However, be careful when working across very wet pools of color, as the dryer can easily blow and smudge your work.

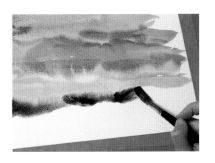

Deceptive color

Do your watercolors always look washed out when you have finished? This may be because you used too little pigment with too much water. Very wet color looks deceptively strong and will dry lighter.

The colors in this variegated wash are still wet and appear bright and vibrant.

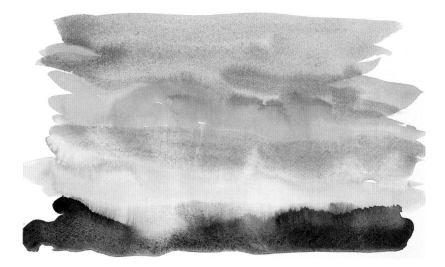

Once dry, they have paled considerably.

Testing color

Always keep a small piece of watercolor paper beside you to test the mixtures and strengths of colors before you use them on your painting. If you note the color mix beside each test mark, you will always be able to remix any color for further applications.

Continued on next page

Excess water

To avoid leaving a thick pool of paint at the bottom of the paper, pick up the paint from the previous stroke as you work your way down the paper, mopping up the edge of the paint as you progress. When you reach the bottom of the paper, carefully pick up the pool of color that has accumulated there with a barely damp brush.

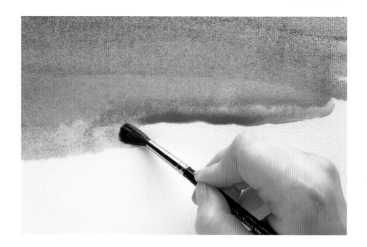

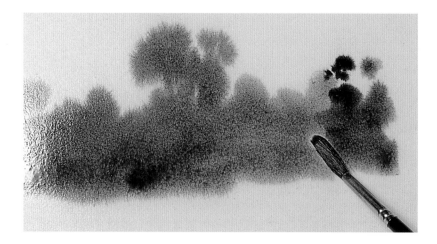

Wet-in-wet

If you always seem to be left with pools of water when creating wet-in-wet washes, you might be applying the second layer of paint before you have allowed the paper to soak up enough of the first wash. As water soaks into paper, it begins to lose its shine. Once a lot of the water has been soaked up, a brush-load of paint will still flow freely, but you will have more control over it. When the paper loses its shine completely, but is not yet dry, you can control the newly applied paint more easily while still being able to achieve soft-edged effects.

Washing off

If you are using a heavy or pre-stretched watercolor paper, you can create a texture effect by laying washes, allowing them to dry, and then washing them off. Place your work at a slight angle, then wash the pigment away carefully with a hose. The harder the spray, the more pigment it will remove. Any very thin applications of watercolor will have been almost totally absorbed by the paper's surface, and very little of the color will wash away. Heavily painted areas, however, can be cleanly washed away and may leave an interesting texture. Remember that staining pigments like alizarin crimson and viridian leave more color behind, while sedimentary ones like cerulean blue and Naples yellow, tend to sit on top of the paper and lift off more cleanly.

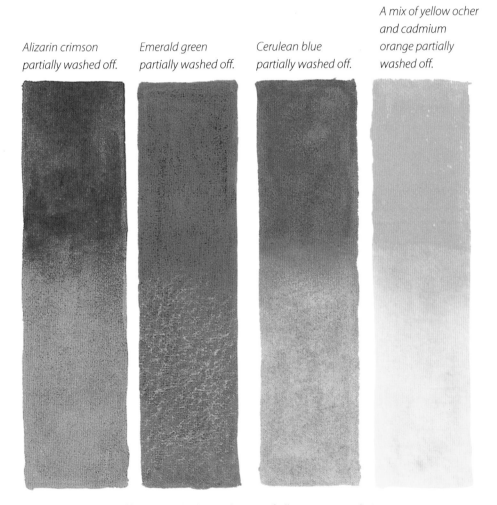

Alizarin crimson partially washed off.

Emerald green partially washed off.

Cerulean blue partially washed off.

A mix of yellow ocher and cadmium orange partially washed off.

Some colors wash off more easily than others, so if all you want to do is texture a wash, take care you don't remove all of the paint. The so-called "earth colors" such as burnt umber and yellow ocher sit on top of the paper, while dye-based colors like sap green and phthalo blue sink into the fibers.

Continued on next page

Meeting an edge

If you only want your wash to cover part of the paper, as in this still life of shells, start laying the wash from the edge of the objects rather than having to meet this intricate edge when finishing the wash. Tilt the wash away from the objects' edges to prevent pools of paint from gathering there—unless this is a desired effect.

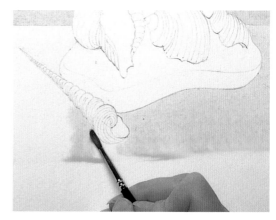

Improved coverage

If white pinpricks appear on the surface of your watercolor paper when you are painting a wash, mixing a drop of ox-gall into the paint. This will both increase its flow and help its coverage.

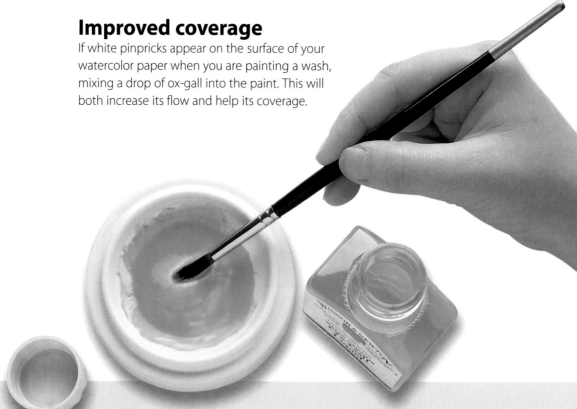

ARTIST'S TIP
If you do not seem able to create clean washes over areas that you have blocked out with masking fluid, try to create the color density and effect you want with only one stroke. If you work over the wash with further strokes, the effect will be less successful.

Under the faucet

Unusual effects can be achieved by running hot or cold water over your painting at various stages of its development.

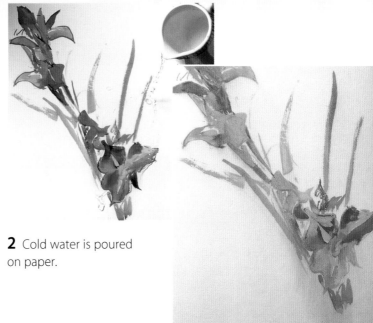

2 Cold water is poured on paper.

3 Paint spreads, blurring lines.

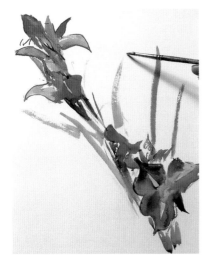

1 Flowers are painted strongly.

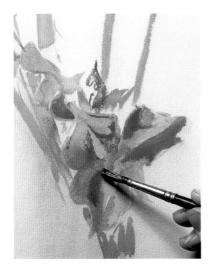

4 More paint is applied.

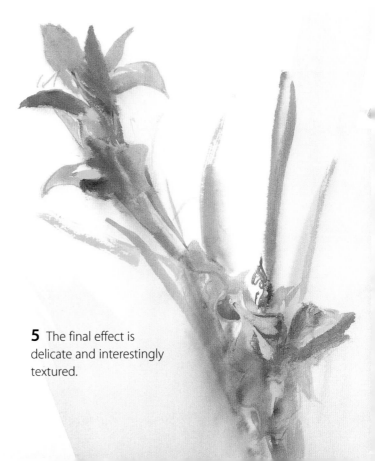

5 The final effect is delicate and interestingly textured.

Traveling light

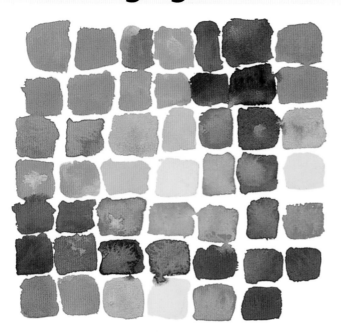

Restricted palette

If you use tube paints and are uncertain which you will need, take only two versions of each primary color—red, yellow and blue. This will give you valuable practice in color mixing and will also help to unify your paintings. Experiment at home before you go.

Range of tones

When painting outdoors, you may not be able to take a wide palette. If you experiment, you will find that with one color you can create infinite tonal variations—for instance, raw umber can vary from a dark brown to a brick brown to an ocher or cream hue depending on how much water is added.

ARTIST'S TIP

If you like to work on tinted paper, prepare it in advance so that when you arrive at your chosen location, you will be ready to start painting. You could even prepare several sheets, mixing up a large quantity of the desired color.

Fingernail trick

When painting on location without your usual "tool kit" use your fingernails if you need to scratch out dry paint for highlights.

Color patches

Choose the colors you will need from a set of watercolor pencils and rub a 2-inch (5-cm) square of dry pigment from each into the last page of your sketchbook. Take this, a brush and some water and, when you are ready to paint, just wet the brush and touch it to the squares of color. You can then blend them and paint on the front pages.

ARTIST'S TIP

If you run out of water or need to mix color on a palette without much water, a touch of saliva makes an adequate alternative to water.

Paper and paints

Keeping paper damp

If you want your paper to remain damp throughout the painting process, place a cloth soaked in water underneath it and leave it there while you paint. To stop the paper from cockling, press it tightly over the cloth and attach the edges to the board with gummed-paper tape.

Testing for dryness

Touching the surface of your watercolor with your fingers to test how dry it is can easily leave grease marks on the paper, which will prevent the paint from adhering. To test for dryness, try using the back of your hand instead. It is a more sensitive receptor than the fingers and will quickly detect any remaining dampness.

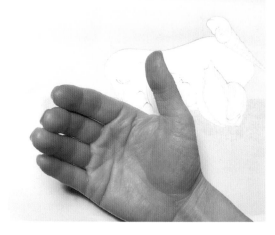

ARTIST'S TIP

Colored pencil or pastel on top of an abandoned or aborted watercolor can pull it all together and create attractive effects at the same time. In Hazel Soan's *Fish River Canyon*, colored pencil gives texture.

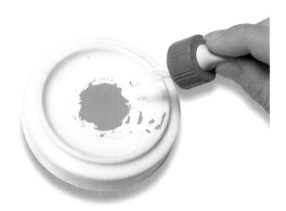

Water quantities

If you have trouble measuring the right amount of water to mix with your colors, try adding the water with a pipette tube. This way, you won't overwater or spill water, and the device is also useful for sucking paint from a palette and storing it in a bottle for later use.

ARTIST'S TIP

If your watercolor paper is too absorbent, or has become roughened by too much rubbing, a thin wash of white or tinted acrylic will seal the surface. When using acrylic for underpainting or corrections, it should be used thinly, or superimposed layers of watercolor may not adhere.

Disguising stains

After washing out a wrong tone or color, you may have been left with a slight stain. You can paint a thin film of white or lightly tinted acrylic over this, smoothing the edges with a cotton swab. When the acrylic has dried, transparent watercolor can be washed over it.

White acrylic masks mistake.

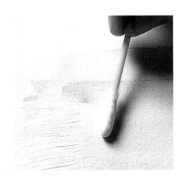

Cotton swab blends white.

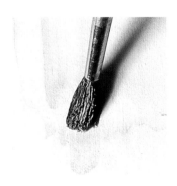

Watercolor is reapplied.

Special effects

Soft glaze

To create a soft glaze over dry work and to vary the surface colors, use a diffuser to blow out a fine spray. For the best results, make sure that the watercolor is completely dry before you add the spray. You can use a mouth diffuser—sold for applying fixative in pastel work—or experiment using a plant sprayer, which is also useful for re-dampening watercolor paper while you are working. Do not hold the diffuser too close to the work while spraying, or you will make areas of the paint run into pools.

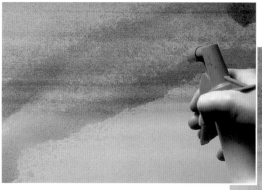

1 A quantity of paint is mixed and applied with a plant sprayer.

2 This creates an uneven "wash," adding surface texture.

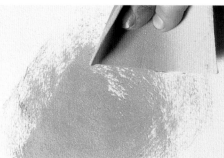

Rubbing into paint with sandpaper.

Experimental textures

Don't be afraid to experiment with texture. Try applying paint with a variety of household items, including potatoes, board, rags, razor blades, sandpaper, rubber spatulas and plastic cards. Try out the effects you can achieve by rubbing or scratching them over the paper.

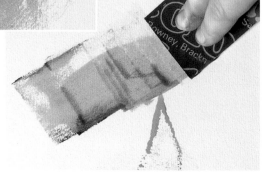

Spreading paint with a cut piece of board.

Ink blots

You can use watercolor inks experimentally to free up your technique and also as a novel way of suggesting the texture of foliage, flowers or pebbles. If you drop ink from a height, it will form a blot. You can produce different effects by changing the height, diluting the ink, tilting the paper, flicking the wet ink to form spatters or blowing on the wet ink so that it makes tendrils.

Sometimes, the random effects formed will suggest a subject that can be developed in a more realistic way; at other times the effects will simply make a pleasing background.

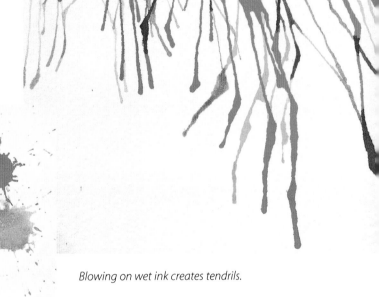

Blowing on wet ink creates tendrils.

Ink dropped from a height blots and spatters.

Experiment with different random effects.

3
Subjects

Landscape **Composition**

When painting a landscape, don't make the common mistake of dwelling on small details to the detriment of the whole. Start by deciding what is most important about the scene and leave out anything that distracts from the main "message." Try to make links between one area of the picture and another so that your composition has a sense of rhythm, and the viewer's eye is led into and around the picture. If you are working on the spot, it can help to half close your eyes to blur the image and reduce detail. Begin by working broadly—many landscape painters start with a series of wet-in-wet washes, building up detail gradually once the main elements are blocked in. Avoid using too many contrasting colors, as this can make the painting look jumpy and incoherent, and use paler tones and colors in the background to give a sense of depth.

Echoing colors

To achieve a unified color scheme, try introducing some of the sky colors into areas of the land. This prevents the picture looking as though it is divided in half. In this painting, worked wet-in-wet, the purple-gray of the clouds have been repeated among the greens.

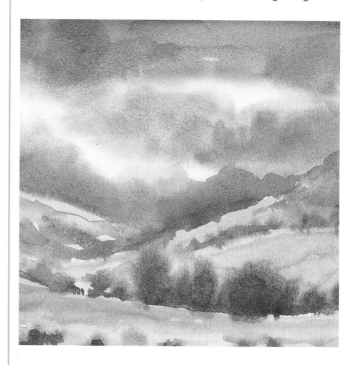

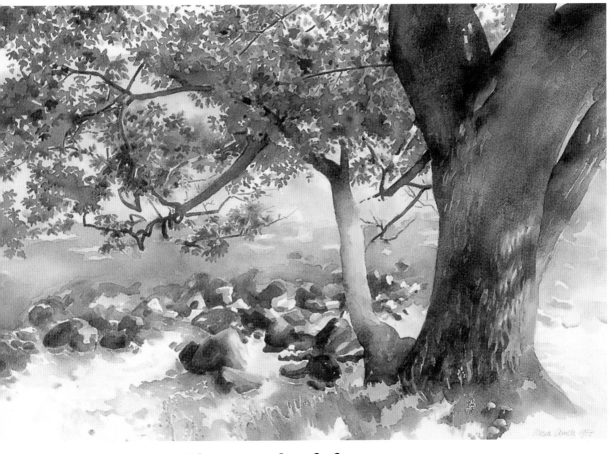

Sharp and soft focus

You can throw certain objects and areas of the
painting slightly out of focus, as Moira Clinch has
done in her painting *Lakeland Tree*. The sharp focus
is reserved for the central area, which is crisply
delineated, while the grass, rocks, trunk and foliage
toward each side are slightly blurred. This prevents
the eye being directed out of the picture by the
swing of the large branch on the right.

Landscape **Fields and flatlands**

Flat landscapes make an attractive painting subject, as they give a lovely feeing of space and freedom, as well as giving you a chance to exploit a large expanse of sky. One of the most important decisions initially is where to place the horizon. It is seldom wise to divide a painting into two exact halves, one for the land and one for the sky, as this weakens the relationship between the two so that composition fails to hang together. A more usual division is to give roughly one third of the picture space to either the land or the sky.

To emphasize the spacious nature of such landscapes you may need to introduce some foreground interest, which has the effect of pulling this area forward and pushing the rest of the landscape back in space. But don't overdo it or it will claim too much attention—often a light suggestion of flowers or grasses, with perhaps one or two scratched highlights is all that is needed.

High horizon

Ronald Jesty has chosen an unusually high horizon for his painting *Poole Harbor from Arne*, making the most of the sweep of the land toward the distant water. The main focal point of the composition is the bright shape of water, placed deliberately off-center, with the strong foreground leading up to it. The side of the brush was used to suggest the clumps of bending reeds, with the paint used fairly dry. The small white shapes of the birds on the right were achieved by scratching back.

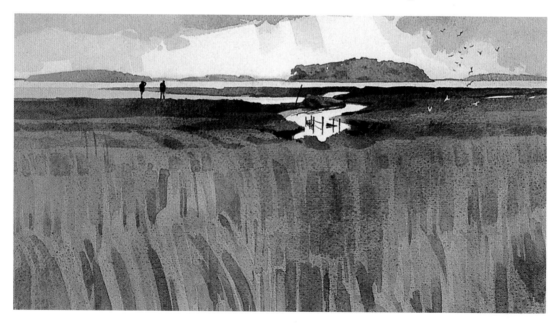

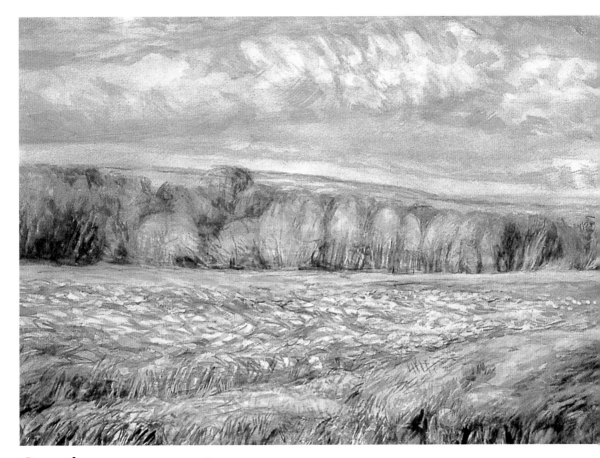

Creating movement

In *Frosty Morning, Autumn*, Donald Pass has used a more-or-less equal amount of detail all over the painting, employing an interesting technique of drawing with the brush in a pencil-like manner, which gives a lovely sense of movement. He has linked the sky to the middleground by using similar shapes for both the clouds and the trees, while linear brushstrokes in the foreground lead up to the central field.

Landscape **Rocks and mountains**

Mountains are a gift to the painter—they form wonderfully exciting shapes, their colors are constantly changing and, best of all, they are far enough away to be seen as broad shapes without too much distracting detail. Look for the main outline, and start with light washes, picking out individual outcrops on those nearer to hand. For atmospheric effects, such as mist lying in valleys or clouds obscuring the tops of mountains, try working wet-in-wet or adding opaque white to the watercolor.

Cliffs and rocks may require a more detailed treatment since their most exciting qualities are hard, sharp edges and texture. Hard edges are best achieved by working wet-on-dry, laying successive small washes and reserving paler highlights, and texture can be produced in a number of ways, such as spattering or dropping salt crystals into wet paint.

Atmospheric perspective

David Curtis has carefully observed the effects of aerial, or atmospheric perspective, which make colors appear cooler and tones paler the farther away they are. By using warm browns and olive greens for the foreground trees, he has pushed the mountains back in space. *The Pass of Ryvan* is a large painting, and was begun on location (uncomfortably) and completed in the studio.

Personal methods

◄ Michael Chaplin has used an unusual method for suggesting texture in his painting *Welsh Cliffs*—that of sandpapering dry washes. This should only be done on heavy paper, and works best on a rough surface. He has also added body color (opaque white) to suggest the chalky surface, and has accentuated the directional brushstrokes in places with light pen lines.

Dark and light shapes

Ronald Jesty's *Portland Lighthouse* derives its impact from strong tonal contrasts, the juxtaposition of shapes and the introduction of red into an almost monochrome color scheme. He has worked wet-on-dry throughout, suggesting texture in places by "drawing" with an upright brush to produce dots and other small marks.

Tutorial **Foreground figures**

Many amateur painters edit the figures out of their landscapes, but this is a pity, because a figure or two can add to the atmosphere and provide a touch of narrative interest. In pictorial terms, figures can also give a sense of scale or provide either a focal point or some foreground interest. Michael Chaplin decided that, for all these reasons, foreground figures were needed for his painting and he drew on a visual reference file of color sketches. He has painted on stretched, cold-pressed paper and uses high-quality sable brushes, vital to his loaded-brush method.

Quick sketch made on the spot.

Color studies provide valuable reference.

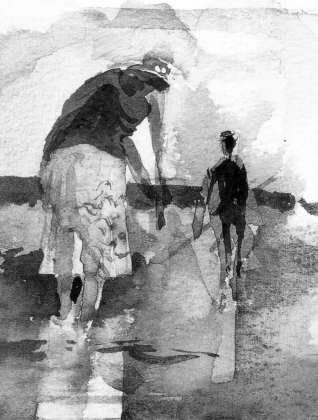

1 The composition of the painting is loosely based on the rapid pencil sketch *(above)*, with the figures brought in from a selection of color studies of people in various postures, one of which is shown *(right)*. For anyone who habitually includes figures in landscapes, visual references—sketches or photographs—are essential.

2 Only the faintest of underdrawings has been made, because the artist likes to have the freedom to make changes as the painting develops. Working with a fully loaded "one-touch," flat sable brush, he lays a light red-brown wash, followed by a darker one that he takes carefully around the white building. The board is tilted so that the color runs down to form dark pools at the bottom of the wash.

3 The cobalt blue used for the sky has been mixed from raw pigment by the artist himself because he likes the granulated effect produced by this home-made color. Another effect he makes use of, this time accidental, is the run of color where the brown wash has flowed into an earlier, very pale color.

4 The white buildings set against the dark hillside are to be the main focal point of the painting, and it is important to establish the tonal contrasts at an early stage. Deep blues have been brought into the hill on the right, and the artist now begins to work on the building, using a diluted version of the red-brown mixture.

Continued on next page

5 He continues to work on the buildings, placing the washes accurately and keeping the lines vertical, but avoiding any precise definition. Throughout the painting, the landscape features are suggested rather than described literally.

6 What gives the painting its freshness and sparkle is the economy of the brushwork: two strokes are never used where one will suffice. Each of the trees, for example, consists of one shaped brushmark, made with a large, pointed sable brush fully loaded with paint.

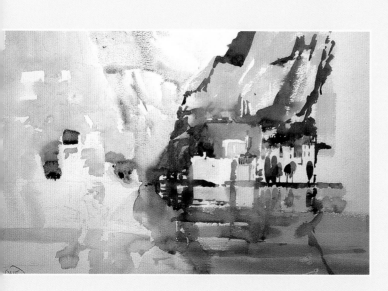

7 So far the artist has concentrated on the right and center of the picture, because this area, with the vertical of the buildings carried through in the reflections, provides the key to the composition. He can now consider the foreground, its figures and the area behind.

8 The artist begins to establish the general structure of the foreground, which will form the framework for the figures. Once these colors and tones are established, he will be able to judge those needed for the figures. To unify the composition, he uses similar red-brown mixtures to those on the roofs and hillside.

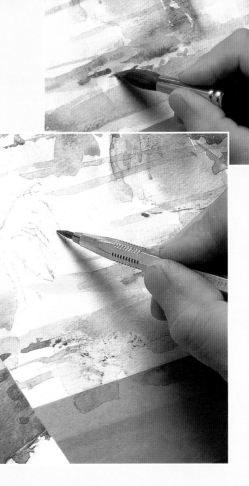

9 A light drawing was made earlier to place the figures roughly and enable him to work around them. Now he refers to his color sketch and draws in the main figure more precisely, making a light pencil outline.

Continued on next page

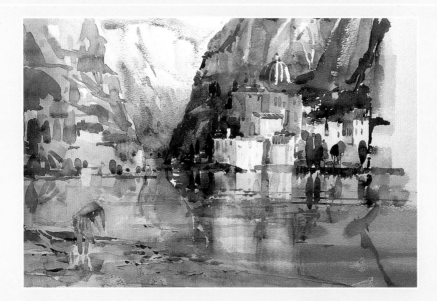

10 With the main figure in place, the artist now decides to introduce another that was not in his sketch. This will strengthen the narrative interest in the foreground and allow him to bring in a further color.

11 The darker areas of the boy's body have been painted over the light colors of the water, but for the pale legs and reflection it was necessary to wash out a little of the red-brown with the tip of a damp brush. The earth colors, also known as sedimentary, lift very easily, because they sit on the surface of the paper without staining it. The highlight on the woman's back has also been produced by lifting out.

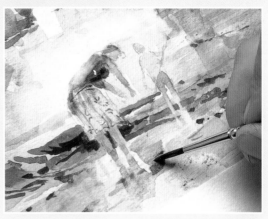

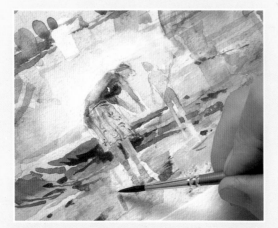

12 The figures are treated very loosely and with the minimum of detail so that they do not stand out too strongly and take attention from the main center of interest. Final touches are made to strengthen the tonal contrasts around them, and to add more red to the boy's body.

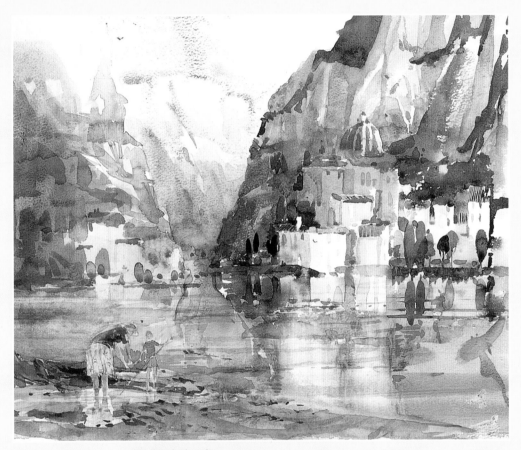

Michael Chaplin

In the Alps

The painting has been worked loosely and freely throughout, and by giving no special emphasis to the figures, the artist has fully integrated them into the landscape. Their obvious absorption in their holiday pursuits adds atmosphere to the scene and brings in a storytelling element seen in many paintings that include figures.

Landscape **Weather**

The look of any landscape is governed by the light it is seen under, and the quality of this light is naturally affected by the weather conditions. If you look at any scene first on a gray, overcast day and then on a sunny one you may be amazed at how even the smaller features of the landscape appear altered, with shadows and highlights defining forms that were previously flat and dull, and colorful shadows creating patterns to enliven flat expanses of ground. A covering of snow also transforms a landscape, and the first snows of winter send artists out in their droves.

But climatic changes are most apparent in the sky, where the weather clouds form and disperse, so watch out for interesting cloud formations and color effects—you can do this from the comfort of your own home if you have a suitably situated window. You may find it worthwhile to take photographs, which you can use as references for later paintings. And don't ignore the possibilities of overcast days, mist or even rain, as all of these can make interesting subjects.

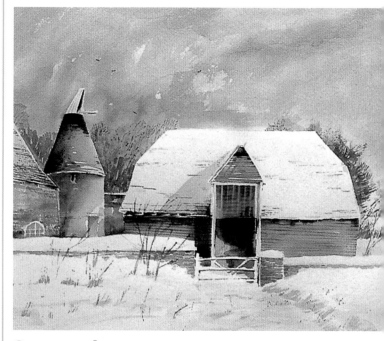

Snow colors

We tend to think of snow as pure white, but on an overcast day, it is mainly shades of gray, and in Michael Chaplin's *Grove Green Farm* there are only pale and darker grays, emphasized by the warm red-browns of the buildings. The painting was done on the spot, with the artist wearing three pairs of socks.

Mist and haze

This lovely painting, *Hazy Sun and Damp Mist, Boulby Down*, almost makes us feel the damp but warm atmosphere. The artist, Trevor Chamberlain, has worked wet-in-wet, carefully controlling the tones and colors, and restricting crisp edges to the roofs of the houses.

Winter sun

In *Winter in Sedgemoor*, Ronald Jesty has slightly exaggerated the brooding purple-gray sky often seen on a late winter afternoon. The composition is bold, with the dark tree and low, red sun counterpointing the brilliant white of the snow, and the dark shape of the water serving as an anchor as well as a balancing shape for the tree.

Landscape **Trees**

Trees, whether green-clad in summer, glowing with reds and oranges in the fall, or starkly naked in winter, are among the most enticing of all landscape features. But they are not one of the easiest subjects to paint, especially when foliage obscures the basic structure and makes its own complex pattern of light and shade. Always look for the main shape first, and then simplify as much as possible, paying special attention to the shapes of foliage clumps and how they relate to the branches and trunk.

Trees in winter are slightly easier, even though the shapes are often complex and do require careful drawing and observation. They make a rewarding subject, as you can exploit special features such as bark texture, holes in trunks, and gnarled, twisting roots. If it is too cold to paint out of doors in winter, there is no reason why you should not work from photographs, which will provide valuable drawing practice.

Winter trees

Martin Taylor is an artist who enjoys detail, and in *Woodland Bank* he has built up the shapes and textures by careful and painstaking use of small brushes. Some of the light areas were achieved by painting over dark watercolor with light acrylic, which he prefers to white gouache.

Pattern and atmosphere

Juliette Palmer's detailed but highly atmospheric painting, *Wood Edge*, was done from her car, a practical alternative to frozen, useless fingers on a cold day. She has concentrated on the exciting, intricate pattern made by the pale twigs, which gives a lovely sense of movement to the painting. Surprisingly, she has used no masking fluid; every tiny highlight was reserved by painting dark around light.

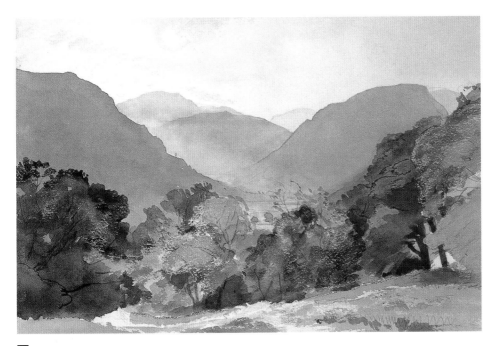

Tree groups

When painting groups or lines of trees in the middle distance, it is vital to look for the main shapes and avoid too much detail. In *Across the Valley*, Charles Knight has painted the trees as a series of washes, slightly varied in tone, and has picked out one or two foliage clumps and branches with pencils and fine brushes. The highlights have been achieved using wax resist.

Landscape **Skies**

Non-artists are sometimes heard to say that if they could paint they would paint nothing but skies, and it is easy to see why. Skies present an ever-changing "free movie show," which is seldom static for more than a few minutes and never repeats the same effect twice. The great English landscape painter John Constable, who was the first artist to study clouds in depth, made endless small studies of skies which he drew on for his large studio paintings.

Clear skies are easy enough to paint, providing you remember that they become paler at the bottom, above the horizon, so lay a graduated wash rather than a flat one. Cloud formations are trickier, as you must take care not to sacrifice the sense of movement and airiness by bringing in too much detail. The golden rule is to work quickly and to simplify if necessary—trying to copy every gradation of tone and color will make the clouds look heavy and solid. It is best to work direct from the subject rather than from photographs, at least initially, as this will force you to work fast and freely.

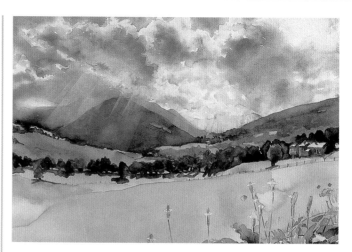

Tonal contrasts

There are often quite strong tonal contrasts as well as sharp definition in the low level of clouds (those nearest to us). As you can see from Moira Clinch's *Mountain Retreat*, the dark shadows in the clouds are only slightly lighter in tone than the mountains. She has given form to the clouds by using a combination of soft shapes painted wet-in-wet, and crisp edges worked wet-on-dry. The effect of the rain was created by careful lifting out.

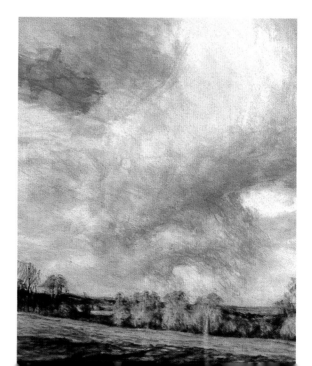

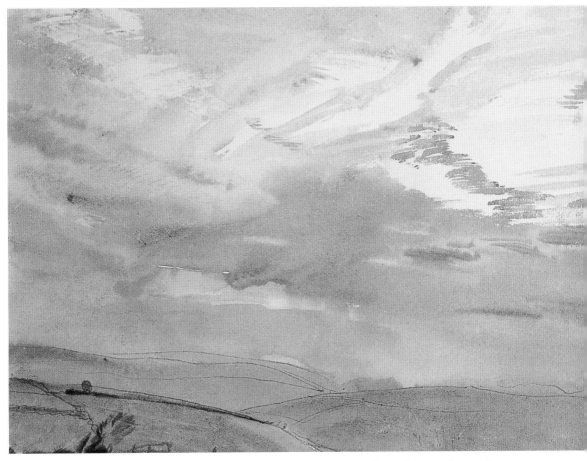

Clouds in composition

◀ Donald Pass's *Spring Shower* is the perfect example of sky used as a dominant feature in the composition. A very low horizon has been chosen, giving the rain-bearing cloud space to sweep down from the right-hand corner to meet the trees in the center of the picture. Dark tones on the underside of the cloud and at the top left of the sky balance the darks in the middleground and foreground.

Anchoring the sky

In Charles Knight's *Sunset, South Downs*, the sky is almost the whole of the composition, but without the suggestion of land below, it would look insecure and insubstantial. It is important to provide an "anchor" for an airy element, and the artist has done this very subtly, with just a few dark lines and small blobs giving a hint of solidity among light washes that echo the sweep of the clouds above.

Tutorial **Using opaque paint**

John Martin's exciting cloud study, painted in gouache (opaque watercolor) on tinted paper, shows how the wonderful colors of clouds can form a painting subject in themselves. He prefers opaque paint because it allows him to build up thick effects and use scumbling and dry brush methods to build up the forms and colors.

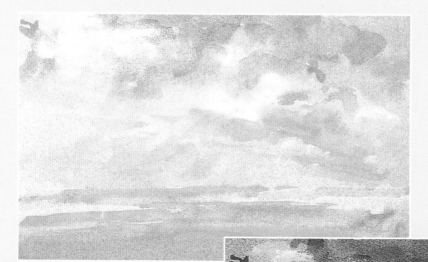

1 He begins in very much the same way as for a transparent watercolor, using the gouache paint thinly. If this paint is used too thickly at the outset, later layers will pick up the underlying ones and muddy the colors.

2 He continues to build up the forms and colors of the clouds, thickening the paint only slightly in some areas, but introducing opaque white at top left.

3 As he works, he gradually thickens the paint, but uses thinner, more transparent colors for the darker areas such as the deep mauves and purple-grays. A final touch is to anchor the sky to the land by making brushmarks of pale, creamy white that provide a muted echo for the cloud highlights. Also, dark blues just deeper in tone than the bottom area of sky are brought in on the horizon to separate the sky from the land.

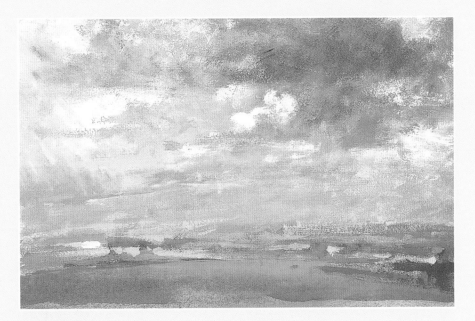

John Martin
Cloud Study
The final touches were to paint a touch of the top of the sky and to add some mid-toned thick paint in the foreground. These link the land to the sky by suggesting patches of sunlight, but no attempt was made at precise definition of the fields and hills, since this would have stolen attention from the real subject.

Waterscapes **Waves**

Waves sweeping onto a sandy beach or breaking over rocks to release showers of spray make a thrilling sight, and stormy seas have inspired painters for centuries. Painting waves requires careful observation, so be prepared to spend time watching how they behave. The movement is basically a repetitive one: the water swells up gradually to form the crest, then curls over and breaks, to be sucked back into the next wave. Unless you work at the speed of light, you won't be able to record the few seconds of drama. So, as with any moving subject, you will have to work partly from memory or from photographs.

You may also need to practice some of the watercolor painter's tricks of the trade, especially when rendering fine spray, which is more or less impossible to reserve as white paper. Try spattering white gouache over dry paint, or using the wax-resist method to give broken white highlights. You could also use masking fluid to reserve the initial highlights, using brushstrokes that follow the direction of the water.

The power of white paper

La Vere Hutchings has caught the sparkling effects of the breaking waves very accurately in her painting, *Monterrey Bay*. For the water, she has used a series of small directional brushmarks rather than flat washes, leaving patches of the paper uncovered. She has given a sense of space by working wet-in-wet in the background behind the plume of water, so that there is no hard edge between the distant land and the sky.

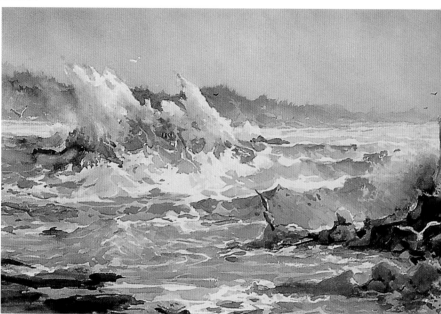

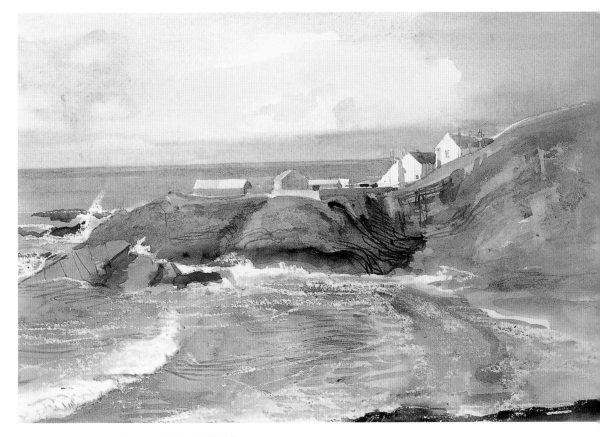

Broken highlights

Charles Knight has used a combination of wax resist and masking fluid for his exciting painting, *Headland*. The fluid reveals pure white paper when removed, but the wax settles only on the raised grain of the paper, resulting in a textured highlight that describes the surface of the water very well.

Waterscapes **Still water**

There are few more tempting sights than the tranquil, mirror-like surface of a lake or expanse of sea on a still day. But although still water might appear an easy subject, many paintings do go wrong, usually as a result of poor observation. A calm stretch of water is seldom exactly the same color all over, because it is a reflective surface. So, even if there are no objects to provide clearly defined reflections, the water will always mirror the sky and show similar variations. Working from photographs is a danger in this context, as the camera does not always catch the subtle nuances of color and tone that the eye can see.

It is also important to remember that water is a flat, horizontal plane. Therefore, if you paint it the same color all over, it will assume the properties of a vertical plane because no recession is implied. It is often necessary to exaggerate a darker tone or to invent a ripple or two in the foreground to bring it forward in space and explain the surface.

Defining shapes

The shapes made by the banks of a river or lake play an important role in defining the water surface, and in *Loch Rannock, Low Water*, Ronald Jesty has placed the dark reflections and small lines of shadow with assurance and accuracy. A sense of space is conveyed by the slightly darker patch of color in the immediate foreground, as well as by the linear perspective that narrows the river banks as it flows toward the lake.

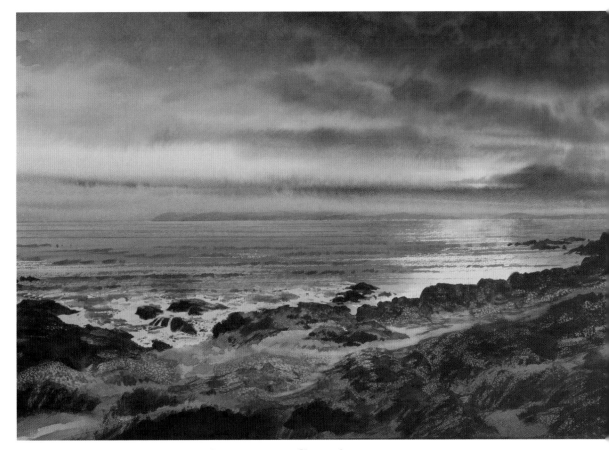

Wet-in-wet reflections

In Naomi Tydeman's *Remains of the Day*, the magical effect of still water under a setting sun has been achieved through a skilfully controlled use of the wet-in-wet method. Tydeman applies a darker wash to a re-wetted sky to create the soft edges of the cloud formations.

Waterscapes **Reflections**

Reflections are one of the many bonuses provided by nature for the delight of artists. Not only do they form lovely patterns in themselves, especially in rippling water, but they can also play a vital role in the composition. In still water, any reflections are a perfect mirror of the objects that cast them—but this does not always make a good painting subject, as the water can lose much of its identity and appear as a vertical surface. In such cases, a touch of artistic license may be needed; you can blur the reflections slightly or introduce some ruffled lines of water to characterize the surface.

Movements in the water cause ripples that present a series of small vertical or diagonal planes. These break up the reflections and scatter them in different directions so that they become separate shapes with jagged or wavering edges. Try to let your brushwork describe these shapes, and take care not to overwork the paint. You could use masking fluid to paint the highlights, removing it at various stages during the painting process.

Composing with reflections

In this bold painting *Old Harry Rocks*, Ronald Jesty has used the reflections as an integral part of the composition, with their curving lines leading the eye into the white rocks that form the focal point of the picture. There is no unnecessary detail, but there is enough variation in the reflection to suggest the structure of the rocks above and the slightly broken surface of the water.

Keeping it simple

John Tookey's painting *Snape* aptly illustrates the idea of "making less say more." The main area of water consists of only two washes, with the first pale one showing through the second to suggest ripples. The reflections have been painted freely, with calligraphic brushstrokes, broken lines and squiggles that describe the way they are broken up by the gentle movement of the water.

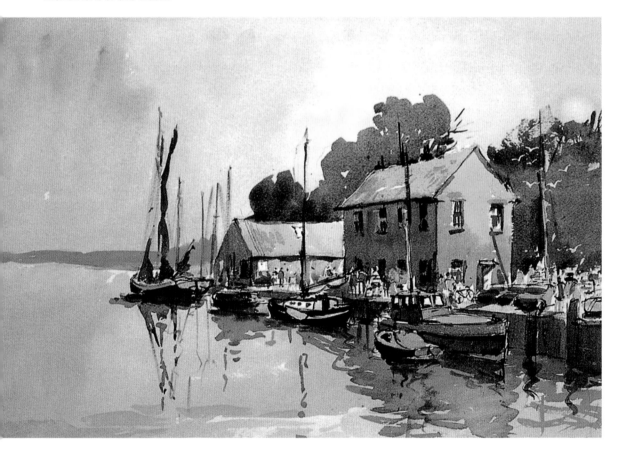

Tutorial **Sky and water**

Waterways and skies can often be painted very simply, and this demonstration shows how just a few washes combined with some wet-in-wet painting can achieve a satisfying result.

1 The artist begins with the sky, laying a diluted purple-gray wash. She has dampened the paper only in the sky area, so the paint stops where it meets dry paper.

2 With the paint still wet, she drops in a strong blue-brown mix to the top of the sky to suggest the soft clouds.

3 When the first washes are dry, she works on the land, laying a wash of strong yellow-brown to the foreground, and leaving an area of white paper for the small pools of water. While still damp, she adds cobalt blue to the mix and works a darker wash wet-in-wet.

4 Having built up more detail on the land wet-on-dry, she paints the distant hills with pale purple-gray, and applies the same color to the sea with the edge of a fan-shaped blending brush.

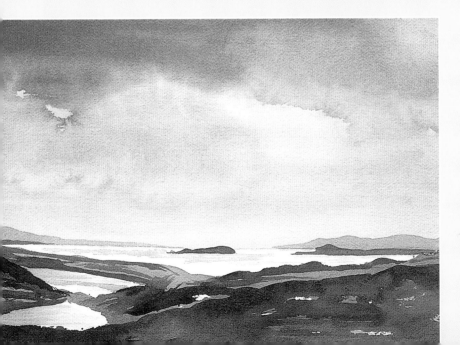

5 Using the same color, but this time working with the tip of a round brush, she paints the reflections below the headland.

Julia Rowntree
Storm Brewing
The painting gives a convincing impression of space, with the sweeping hills and broad expanses of water stretching away into the far distance.

Buildings **Lighting**

Light is the single-most important factor in painting—without it, nothing would exist. Light is especially vital when painting buildings, as it is the play of light on the vertical planes that describes their structure and brings out their color and texture. Shadows, too, play an important descriptive role, as well as adding an extra element to your painting. So, in general, it is best to avoid overcast days or times of day when the sun is high overhead.

A low sun, in the evening or early morning, will cast long shadows and accentuate colors, making a building come to life. An ordinary, drab, brick-built row house, for example, will suddenly present a range of glowing colors from golden yellows and oranges in the sun-struck areas to purples and blues in the shadows. If you are more concerned with the overall shape than with colors and texture, however, then backlighting can be effective. A castle or ruin silhouetted against a stormy sky or sunset can make a thrilling and dramatic subject.

Waiting for the sun

John Tookey has wisely waited for the right time to paint his *Venetian Backstreet*—when the sun has turned the right-hand building a rich gold and cast a slanting shadow across the street. Imagine what this scene would look like under a gray drizzle; it would have little interest for the artist because there would be almost no color or tonal contrast.

Painting light

Trevor Chamberlain's major interest is in the effects of light, and in *Old Wharf at Rotherhithe* he has made the most of a low evening sun.

Mist effects

A misty, diffused light has allowed Michael Cadman to simplify the complex forms in his *Gloucester Cathedral*. Although there is a considerable amount of detail on the building, it is subjugated to the shape and color, and the lines have been softened by working into a slightly damp initial wash.

Buildings **Atmosphere**

Buildings, towns and cities all have their own characteristic atmosphere—a town might be described as busy, bustling and happy or perhaps dull and depressing, while an individual large building might attract adjectives such as brooding or majestic, and a small one might imply elegance or coziness. It is important to try to convey some kind of feeling through your paintings, and you can do this by choosing a certain time of day or by including figures, cars, bicycles or whatever may be typical of the place. You can also suggest atmosphere through your use of paint and choice of colors. For example, broad washes and a muted color scheme give a restful impression, while small brushstrokes and bright colors suggest activity and liveliness.

Time of day

Venice, that most atmospheric of all cities, loses a good deal of its identity when thronged with brightly clad and loud-voiced tourists, and Alan Oliver has chosen a misty early morning for his evocative painting. To create soft effects, he began by soaking the paper and then applied variegated washes of pink and yellow to suggest the warmth of the rising sun. He then worked mainly wet-in-wet, adding the crisp details by layering washes wet-on-dry.

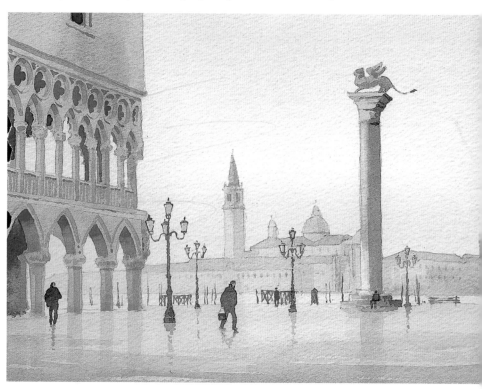

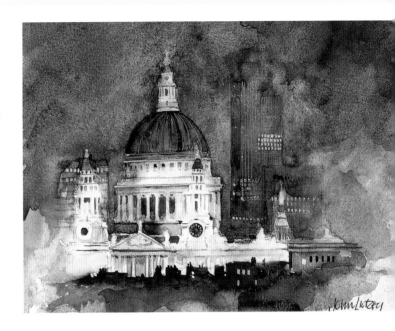

Use of paint

In *St Paul's at Night*, John Lidzey has created atmosphere less through the choice of subject than through the way he used the paint, with carefully controlled wet-in-wet work contrasting with slightly sharper definition on the building. Although the details were painted wet-on-dry, the brushstrokes were softened with damp cotton swabs to retain the same feeling throughout the painting.

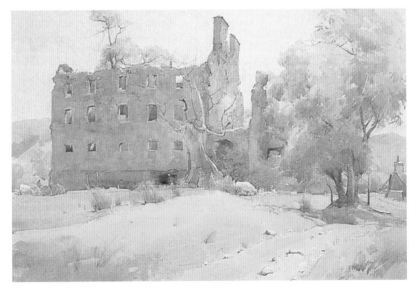

Ruined buildings

Ruins always have a distinct atmosphere, as they tell a story, sometimes sad and sometimes exciting. In *Ruined Barracks, Scotland*, David Curtis has stressed the empty loneliness of the building by including much of the landscape setting, pushing the building itself back in space.

Buildings **Texture and pattern**

Man-made structures provide as much variety of texture and pattern as the natural world, and it is often these that attract us to a particular building rather than its shape or proportions. Building materials vary hugely, from wooden boarding, bricks and stones to expanses of reflective glass, and it would be a pity to ignore the inventiveness of generations of architects and builders. Also, giving an indication of the building materials helps you to impart a sense of place as well as making your paintings look more realistic in terms of structure.

The amount of texture and pattern you include depends on your approach. You can paint every brick, stone and tile, or you can give just a light suggestion and pick out one or two details. The texture of an old whitewashed wall or stone house might be suggested by the wax-resist or dry-brush methods, or by drawing lightly over watercolor with pastel or colored pencils.

Town houses

Martin Taylor is an artist who loves detail and, typically, he has included every brick, tile, flagstone and blade of grass in *Up the Garden Path*. He paints slowly, working on one area of the picture at a time, and achieves depth of color by repeated overlaying of small brushstrokes.

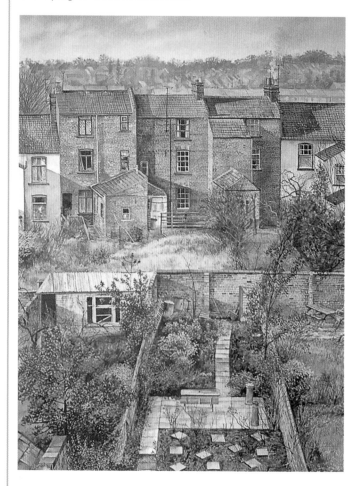

Atmospere through texture

Sandra Walker is fascinated by the atmosphere and texture of buildings, and has painted a series of large works portraying London's crumbling East End. Because of the careful attention to texture, built up by spattering, dry-brush work and scraping with a blade, this detail tells us more about the building than the whole structure would.

Buildings **Buildings in landscape**

In a town- or cityscape, buildings are the whole subject of the painting, but an individual building such as a farmhouse or church, or even a small village, can also be part of a landscape, forming just one of its features. This is a subject with great potential, because it allows you to exploit the contrast between natural and man-made forms. However, there is a danger that the contrast can be too strong, so stick to buildings that look at home in their settings rather than out of place.

Many old buildings appear almost as though they have grown naturally out of the landscape, often because they are built from local materials and reflect the prevailing colors. So try to achieve this kind of unity in your paintings, especially in technique. Buildings are harder to draw and paint than trees and rocks, so there is always a tendency to treat them in a tighter and more detailed way than the landscape. This will make the picture look disjointed, so if you are painting the landscape wet-in-wet, do the same for at least parts of the buildings.

Choosing the viewpoint

In Martin Taylor's *Castello di Tocchi* the buildings are totally at one with the landscape, and the artist has chosen to paint them from the back rather than the front to give a less grandiose impression. Notice how he has created a lovely sense of space by allowing the sky to occupy a large part of the picture area. He has also included a swathe of landscape in the foreground to push the buildings back in space.

Relating buildings and setting

In Juliette Palmer's *The Pathway to Molière Cavaillac*, the buildings are so well integrated into the landscape that they almost seem to be organic forms, like the surrounding rocks and trees. This impression is reinforced by the artist's unusual and very individual technique, which stresses pattern by means of small, light brushmarks of different shapes and sizes.

Buildings **Interiors**

Interiors are a "cross-over" subject belonging to two categories—buildings and still life. A detailed painting of the interior of a cathedral would class as an architectural study, while domestic interiors such as your own kitchen or sitting room are more akin to still life. This kind of interior presents a wealth of possibilities, one of the most exciting being to explore the effects of light on familiar objects at different times of the day. You don't have as much control as you do over a small still-life setup, but you can usually move chairs and tables around as well as rearranging any objects on them, and remove or edit out any unwanted pieces of furniture.

If you are especially interested in light effects, bear in mind that they don't last long, so you may have to work in several short sessions at the same time of day. Alternatively, you can take photographs as a reminder, and work from a combination of these and the subject itself.

Soft light

In his *Interior with Desk and Chair*, John Lidzey has achieved a lovely, soft, luminous effect by frequently blotting his freely applied paint with damp cotton waste, sometimes completely removing and re-applying areas of color. This ensures that there are no obvious brushmarks, which he dislikes, and gives a pleasing granular texture to the paint.

Surface texture

John Martin's *Pinda Cottage* is painted in opaque watercolor (gouache), which has allowed him to give additional texture and color variations to the walls by means of overlaid brushmarks. The focal point of the composition is the window, with its framed view of the buildings outside, and the eye is led toward this by the diagonals of the left-hand wall.

Still life and flowers **Composition**

The beauty of painting still life is that you have complete control over the setup, and can arrange your chosen objects in any way you like, thus partially composing your picture before you lay brush on paper. You can also work at your leisure—although the light will change as the day progresses, the objects themselves won't move, so you can work over a period of days if required. Indoor flower arrangements will usually have to be done in one session, as buds open and flowers wither very quickly, but even so, you will have more time than you would do for an outdoor subject.

Whether you are painting flowers, fruit or a group of bottles, take time over the initial arrangement, and look at it from different angles through a viewfinder (a piece of card with a rectangular aperture cut into it). You may find that a straight-on view provides a less interesting composition than an angled one, or that a high or low viewpoint works well. High viewpoints are often chosen for still life, as they bring in a pattern element.

Looking from above

Doreen Bartlett has chosen a very high viewpoint for her painting *Bowled Over*, making an exciting composition based on circles and curves—don't ignore the possibilities of setting up your still life on the floor. The very controlled blends on the fruit were achieved by working wet-on-dry with the minimum amount of water.

Choosing backgrounds

Backgrounds are every bit as important as the objects themselves, so choose with care. Newspaper, although an unconventional setting for flowers, works wonderfully well in Ronald Jesty's *Sweet Peas in a Tumbler*, with the monochrome images providing just the right combination of geometric shapes and dark tones to balance the rich colors of the flowers.

Still life and flowers **Arranging**

Still life, like any other subject, should have movement and dynamism so that the eye is led into and around the picture. Never arrange your objects in regimented rows with equal spaces between them, as this will look dull and static. Instead, let some of the shapes overlap others; this will not only create links between the various objects but will also help to explain their relative positions in space. Pay attention to the spaces between objects so that they themselves form pleasing shapes—these "negative shapes" are often overlooked, but they play an important part in composition.

The angle of viewing is important, as diagonals formed by the front and back of a table top when seen from an angle can be more interesting than the horizontals given by a straight-on view. However, there are many ways of breaking up horizontals, a common device being to arrange a piece of drapery so that it hangs over the front of the table and makes a rhythmic curve around the objects.

Ready made themes

Sometimes, a theme for a still life will be suggested by daily life; plates and cutlery after a meal, for example, are popular subjects, but they do nearly always need some rearranging to make a good composition. In Carolyne Moran's *Time for Tea*, the objects have been carefully grouped so that they form a rough triangle, with the lid of the teapot at the apex.

Cropping

▶ Arranging the group is only the start of the process of composing the picture. Shirley Trevena makes no preliminary drawing and composes as she paints. In *Black Grapes and Wine*, she has decided to crop both the plate in the immediate foreground and the bottle at the top. Cropping, sometimes called "busting the frame," gives an impression of freedom—the objects are not confined by the frame, but appear to continue their existence outside it.

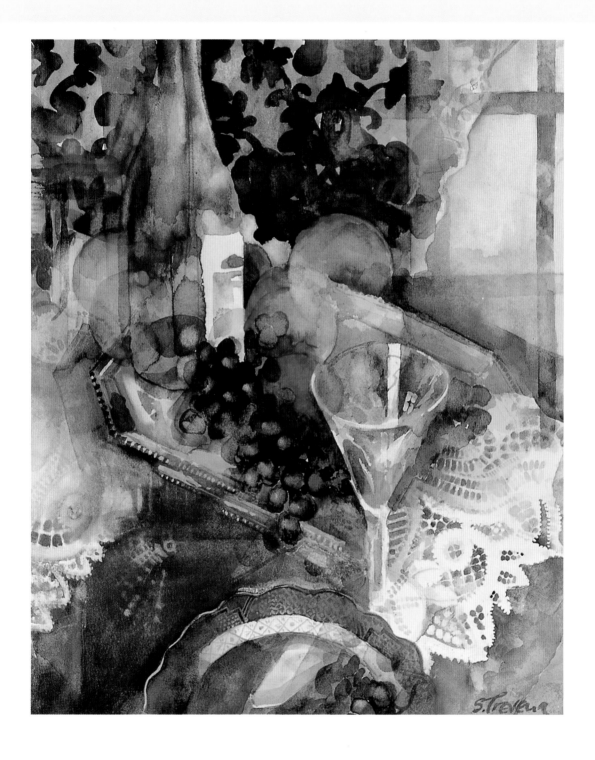

Still life and flowers **Color scheme**

There are two basic types of color scheme—contrasting and harmonious—which each create different moods. Contrasting color schemes use bright primary colors or complementary colors (those opposite one another on a color wheel, such as red and green). These give an impression of liveliness and excitement, while harmonious schemes, based on related colors (close to one another on the wheel) are quieter and more restful.

In landscape painting, you will normally tend toward the latter type of color scheme because nature's colors are naturally harmonious, but in still life and flower painting, you have a choice. You might set yellow flowers against a purple background for drama, or use a neutral brown background for a gentler effect. The only danger with harmonizing colors is that they may become rather dull, so try to bring in touches of subtle contrast to enliven the image.

Dominant colors

The color scheme of a still life is often dictated by one dominant color, as in Geraldine Girvan's lovely *Winter Oranges*. The blues of the background and the dark tones in the foreground provide a foil for the fruit, which stand out in the center of the picture.

Muted contrasts

▶ Shirley Felts has handled the color very cleverly in her lovely *Still Life with Apples*. This is basically a harmonious color scheme, but she has brought in contrast by using a reddish brown to offset the greens. Red and green are complementary colors, and if both had been used at full strength, the effect could have been jarring, but this muted color has enough red in it to make the brilliant greens of the apples sing out. The dark tones contribute to the restful feeling—tonality also plays a part in conveying mood.

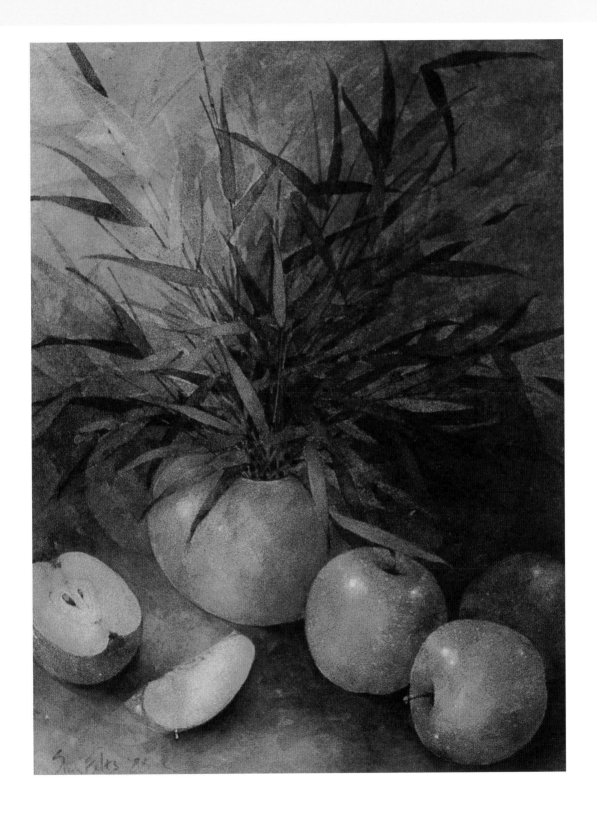

Still life and flowers **Natural habitat**

Oddly, the term flower painting immediately conjures up an image of cut flowers in a vase rather than one of wild flowers on woodland banks, perhaps because most of us spend so much more time indoors than out. But flowers are at their best in their natural habitat, and some, of course, can only be seen there as they can't be picked, so if you enjoy painting flowers it is well worth making field trips.

Painting specimens from life is rather more difficult than painting cut flowers. Apart from the physical problems of finding somewhere comfortable to sit, you will have to contend with changing light. As the sun moves across the sky, a leaf or flower head that was previously in shadow will suddenly be spot-lit so that you can no longer ignore its presence. One way to deal with this, if you can count on consistent weather conditions, is to work at the same time on successive days, and another way is to make quick studies that you can combine into a painting later. You can also take photographs, though, unless you are a practiced photographer, these are not always entirely reliable.

Pattern in composition

In *Rhododendrons in Dulwich Park*, Audrey Macleod has used the shapes and forms of the plants to create a composition with a strong two-dimensional pattern quality. To express the delicacy of the subject, she has used the line and wash technique to set up an effective hard/soft contrast, retaining the freshness of the paint by touching the color in lightly to the edges of the forms.

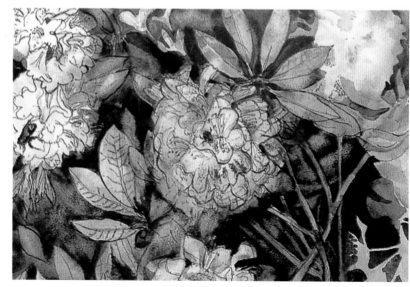

Working from photographs

Norma Jameson works partly from life and partly from photographs, as she says that the former gives the necessary element of spontaneity while the photographic studies allow her time for consideration. For *Waterlilies*, painted in watercolor and gouache on smooth paper, she took numerous photographs from different angles and positions, using the camera as a sketchbook.

Still life and flowers **Garden settings**

Gardens are ideal places in which to study and paint flowers, and unlike woodlands and other natural landscapes, they usually provide places to sit in comfort. If you have your own garden you can enjoy immortalizing a special flower or shrub that you have grown yourself and are proud of, but if not, there are usually public parks where you can work if you don't mind being watched.

As with any outdoor subject, you will have the problem of changing light, and more importantly, that of deciding on a composition. The primary consideration is whether you want to take a broad view of a mass of flowers or home in on one or two individual plants. If the latter, you will have to be very selective, as there will be many other plants around and behind your chosen ones, and you will have to simplify so that your composition doesn't become too cluttered. One approach might be to paint any flowers in the background wet-in-wet, with soft edges, building up the main plants in more detail wet-on-dry.

Massed flowers

Pink Roses, White Phlox by Juliette Palmer is a painting of the artist's own garden and, not surprisingly, she has decided to paint a large area of it, together with the tall trees that form an ideal backdrop. She is fortunate enough to have a strong sense of design and composition, and says that as she observes a subject, various elements will fall into place to form a satisfactory whole.

Single flowers

Elena Roche chose a classical style of composition for her painting of this vibrant Canna in her garden. Sketched and painted from a shady position, the artist applied a resist to the leaves before individually wetting and painting each leaf and flower.

Still life and flowers **Botanical studies**

Nowadays, watercolor is thought of primarily as a spontaneous, free medium, but it was not always used in this way, and can be very carefully controlled. Botanical studies have been made in watercolor for many centuries, and it is still the chosen medium for today's botanical illustrators.

Painting single specimens of plants and flowers requires extremely careful observation, good drawing and a lot of practice, but it can be very rewarding. Such paintings make lovely greetings cards too. Professional illustrators usually work from life, making sketchbook studies and then working out the composition in the studio—but you might start by copying from old illustrated books or even tracing from magazines and seed catalogs. Copying is quite acceptable if done for learning purposes, and you can graduate to real-life studies once you have mastered the techniques.

Dramatic emphasis

The shapes and structures of some flowers are so fascinating that they seem to demand the right to be seen alone, with no distracting background or other objects. This is certainly the case with *Crown Imperial* by Jenny Matthews, and the artist has made the most of her chosen specimen through her tough but sensitive use of linear brushstrokes.

The scientific approach

Sharon Beeden is a professional botanical illustrator, and *Apples and Plums* was one of a series done for a book on the introduction of fruit, vegetables and herbs to Britain through the centuries. Sketchbook studies formed the basis of the composition, which was worked out on tracing paper and then transferred to the working surface.

Tutorial **Exploiting edge qualities**

Adelene Fletcher specializes in watercolor flower painting, and this painting clearly shows how her experience and skill in handling the medium contribute to the overall effect (see page 177 for the finished picture). She has painted the background and vase with loose, wet-in-wet washes that contrast with the crisp definition of the flowers, creating a strong feeling of three-dimensional space.

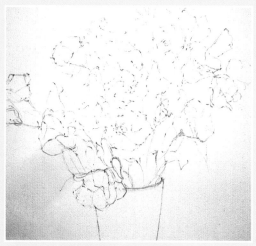

1 The artist is working on cold-pressed paper, in a weight heavy enough not to need stretching. She starts by making a careful outline drawing in pencil, concentrating on the shapes of the flower heads and the angles at which they are seen.

2 The first stage is to indicate the highest colors. She works wet-in-wet for these first washes, starting with yellow and then dropping in touches of rose pink with the tip of the brush. She has dampened the paper only where she wants the colors to run into one another.

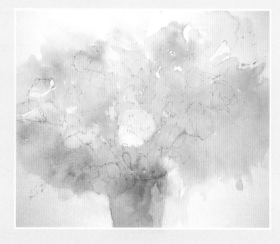

3 The rest of the picture, except for the background, will be worked wet-on-dry, with the wet-in-wet underpainting providing a guide for the choice and placing of the subsequent colors.

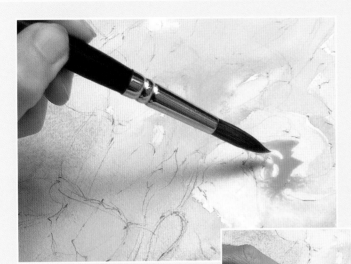

4 The artist uses the classic watercolor method of building up from light tones to dark in a series of layers. She has left the wet-in-wet washes to dry, and starts to build the colors and shapes of the flowers, taking a deep pink around the penciled outlines of the central stamens.

5 Here, again, you can see how vital it was to draw the pencil outlines accurately. The deep green defines the edges of the petals and leaves, and must be taken around them with care and precision.

6 The artist works over all areas of the painting at the same time, rather than bringing one area to completion before another. She continues to build up the depth of color in the flower heads, placing her washes so that they create crisp edges that define the shapes.

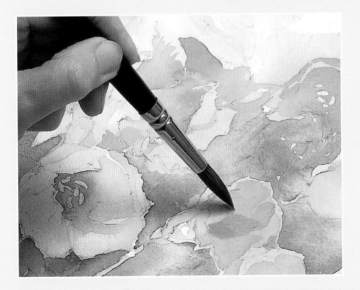

Continued on next page

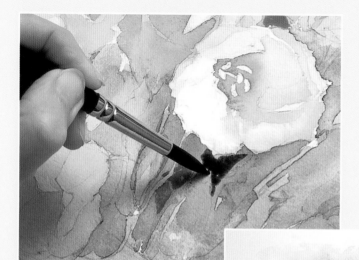

7 At this stage, with the main colors established, she can start to bring in more depth of tone. Using a pointed sable brush, well loaded with paint, she takes dark green around the stems and bottom of the flower.

8 The half-completed painting shows the combination of the two main watercolor methods, wet-in-wet and wet-on-dry. The latter gives sharp, crisp edges that make the flowers stand out against the softer, wet-in-wet work.

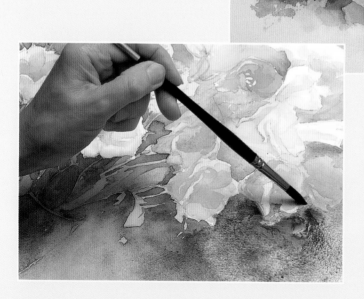

9 For the background, an amorphous area of dark tone that contrasts with the crisp edges and delicate colors of the flowers, the artist returns to the wet-in-wet method. She lays the board flat so that the colors flow into one another but do not run down the paper.

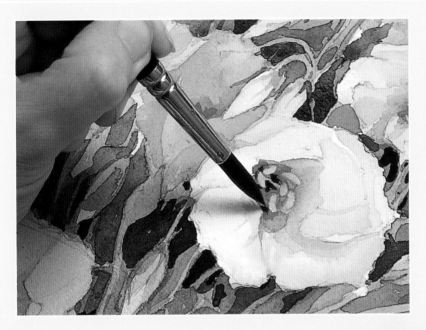

10 Further dark tones have been laid around the stems, creating a lively pattern of light and dark, and the artist now builds up the form of the middle flower, dropping small touches of very deep color into the center. The stamens, originally reserved as white highlights, have now been darkened, as they are in shadow.

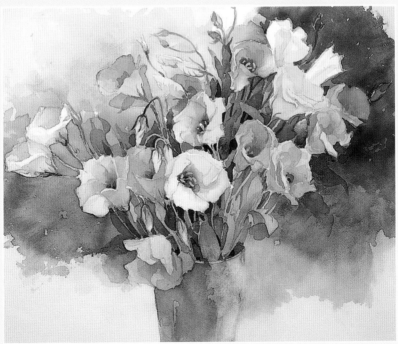

11 The painting is now almost complete, and could be left at this stage, but the artist decided that the background would benefit from a touch of additional color and interest.

Continued on next page

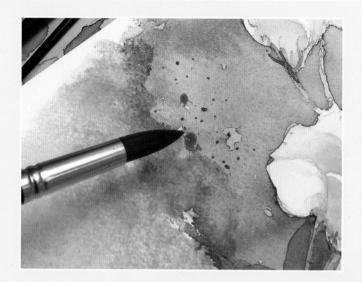

12 Pinks appear among the wet-in-wet background colors to provide a link with the flowers, and this link is now strengthened by flicking droplets of deep mauve-red over the green in the left-hand area.

13 Yellow has already been introduced beneath the green on the right-hand area of the background, and this is now used again on the other side so that the two areas of background balance one another. Touches of this same yellow appear on the light-struck sides of the central flowers.

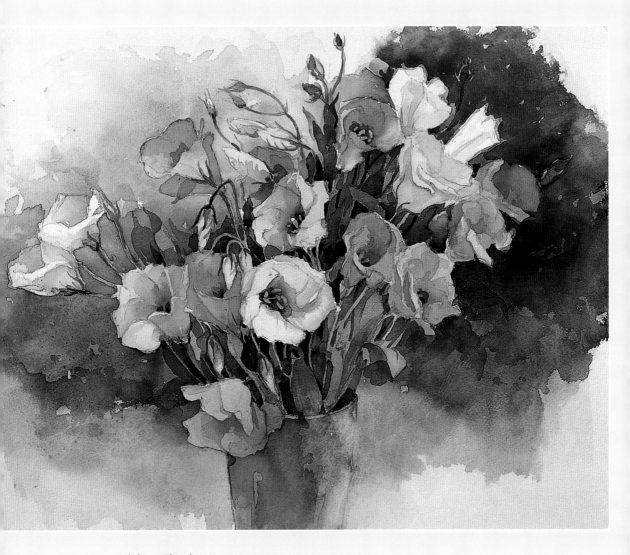

Adelene Fletcher
Flower Piece
The finished picture has the lovely, fresh sparkle that
characterizes the best watercolor flower paintings, but it also
has considerable strength, with the flowers firmly modeled
and the composition planned with care.

People **Figures in landscape**

Beginners often shy away from including figures in landscape paintings because they are hard to draw. This is a pity because one or two figures or a small group can often bring a scene to life, providing a story-telling element. A beach, for example, usually has family groups in summer, and even in winter you will often see a few lonely figures walking dogs or simply taking exercise after a meal. Figures can often be sketched in quite simply with one or two brushstrokes, and will look convincing provided you observe the general shapes and postures accurately.

Figures also give a sense of scale. We can't tell from a painting whether a tree or a rock formation is large or small unless we have something familiar to compare it with. However, we all know the average size of our fellow humans, so putting in a figure at the base of a huge tree acts as yardstick to help us judge the size. This can add drama or even give a sense of menace—JMW Turner was fond of including small figures in mountain scenes to stress the power of nature over helpless humankind.

Leading the eye

Because we naturally identify with our fellow humans, our eyes tend to follow them, so that they serve a purpose in leading in from one part of the picture to another. In Jann T Bass's painting *Hazy Glint*, the two figures provide a link between the foreground, middleground and distance as well as adding to the atmosphere of the scene.

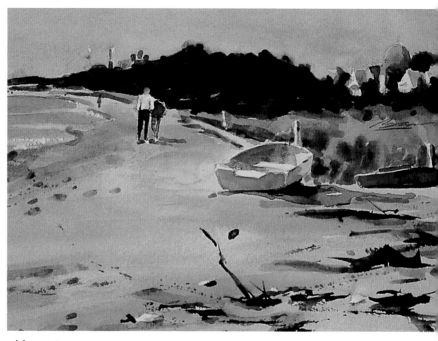

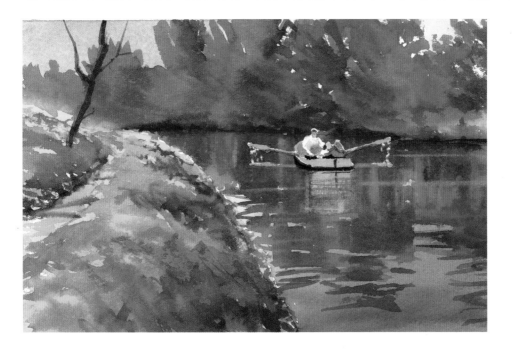

Telling a story

Joe Dowden's *Rowing Boat in Woodland* depicts a man rowing in the middle distance with two figures huddled in the boat. The scene arouses our curiosity. This kind of narrative element can make a painting more interesting, and is often evoked through the inclusion of figures.

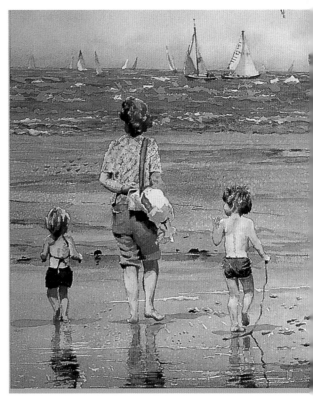

Attracting interest

In this painting by La Vere Hutchings, *A Day at the Beach*, our eyes are drawn to the drama of the racing yachts as we follow the gaze of the mother and children. These figures are meticulously observed and painted with great care so that they are almost portraits, instantly recognizable to anyone who knows them.

People **Portraits**

There is no doubt that portraiture is a tricky subject unless you have that happy knack of capturing a likeness, as some people do (this does not necessarily make them good artists). But although the subject is often believed to be especially difficult in watercolor, this is not really the case, and more and more artists are turning to the medium to produce fine and sensitive portraits.

The most important skill associated with portraiture is drawing. No good painting can be built on a shaky foundation, and it is essential to understand the structure of the face and head as well as being able to identify and analyze the individual features that make each face special. A good way of getting to know the basics is to use yourself as a model and start with a self-portrait—there are few artists who have not drawn and painted themselves at some time. Drawing and painting from photographs is also good practice, but it is best to work from life whenever possible, as this allows you to see the head and body from different angles and build up a more complete picture.

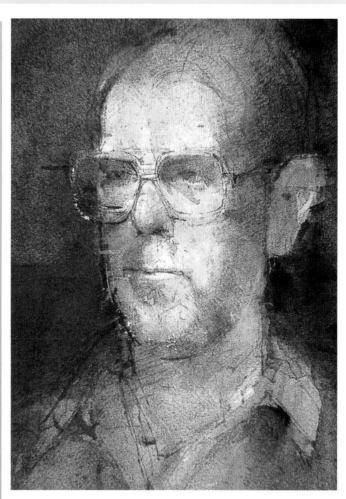

Head and shoulders

Portraits fall roughly into three types—head and shoulders, three-quarter length and full length. In the first, the body is usually cropped at a convenient place between the chest and neck. In Michael McGuinness's *Bruce*, the bottom of the shirt opening makes a good stopping point, providing a pale triangular shape that balances the oval of the head.

Informal portraits

You don't have to pose your subject formally to achieve a good likeness, as people's habitual poses, body language and typical dress are often as recognizable as their faces. Trevor Chamberlain's *Armchair Gardener* might not be officially classified as a portrait, but it is obviously an excellent likeness, and like all good portraits, makes us feel we know the sitter.

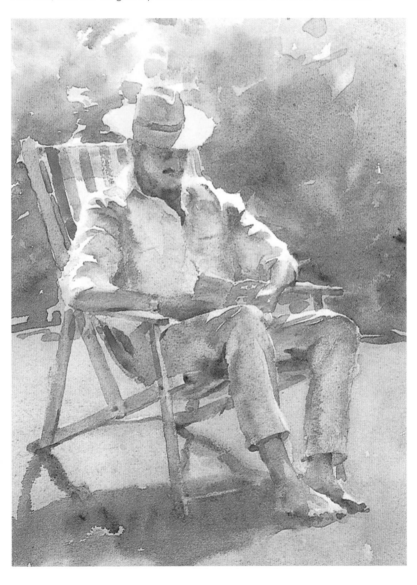

People **Children and young people**

It is most unlikely that you will persuade anyone under the age of 20 to pose for long periods, so to paint young people, you will usually have to work from photographs or sketches, or a combination of both. Sketching is not usually a problem, as children often stay still for long periods watching television, drawing or doing homework.

You will need to aim at a natural, relaxed look, so you might ask your model to pose for a photograph or sketch in a favorite item of clothing—this might be a party dress, a beloved pair of old jeans or a fancy-dress outfit. Take care with technique, as the faces and bodies of young people are softer than those of adults, with less prominent bones and hard edges where different planes meet. You could try working on slightly damp paper, or use a damp brush to soften any hard edges that form where they are not wanted.

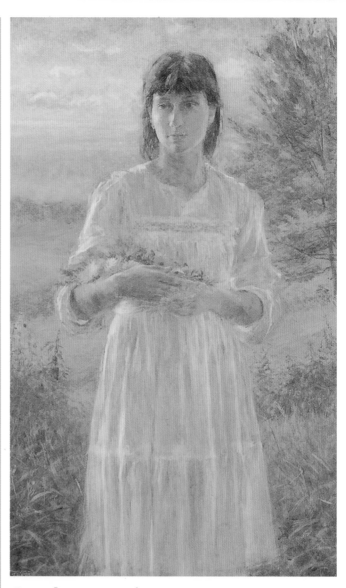

Outdoor settings

Jacqueline Rizvi's choice of a landscape setting at sunset enhances the period flavor of her delightful painting, *Sarah as Perdita*. The artist achieves her soft effects by mixing watercolor with opaque white and building up slowly, layer by layer. This painting, on brown paper, was worked on over a period of two or three months.

A sense of identity

Audrey Macleod's *Portrait of Stephen Ebbett* was a commissioned work, painted on smooth paper with a little gouache added to the watercolor. When painting children, the artist likes to use familiar toys and possessions to give a sense of identity, and here she has also used the surroundings to give a sense of scale—with the high table and windowsill with its teddy-bear-sized cat dwarfing the little boy's miniature chair.

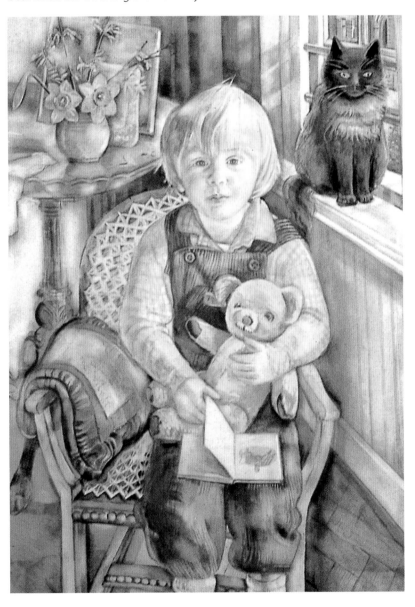

People **The figure in context**

Because the figure is a complex subject, there is tendency to lavish all attention on it and ignore the setting, but this is not wise; every subject needs to be seen in context, whether outdoors or in, and it also increases the compositional possibilities. The environment can also provide important clues about the person and his or her way of life, just as clothing does. Some of the most successful figure paintings of figures show people in their place of work or engaging in their chosen activities, the marvelous series of ballet dancers by Degas being among the most famous examples.

Indoor figure paintings are perhaps the easiest to manage, as you can control the lighting, the background and any additional "props"—such as furniture—that you may want to include in the composition. But if you intend to paint an informal portrait of someone who enjoys gardening or hill climbing, it makes sense to choose an outdoor setting. You will, of course, have to cope with changing light and the other problems associated with outdoor work, but you can work from photographs or compose the picture from sketches made on the spot. If you are taking the latter course, don't forget to indicate the direction of the light, as this may play an important part in the atmosphere as well as helping to make the figure look three-dimensional.

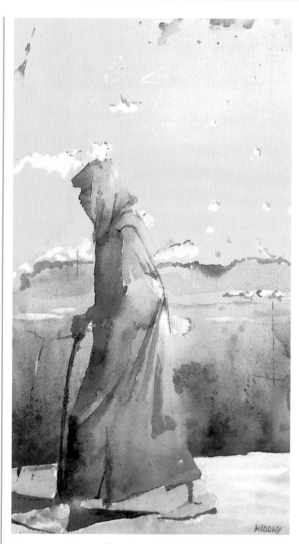

A sense of place

In Paul Millichip's *Berber*, the figure is totally at one with its surroundings, and the painting is full of atmosphere, suggesting a whole culture and way of life specific to a certain place. The artist uses a limited palette of no more than six colors, with no premixed secondary or tertiary colors, and he paints very wet (but not wet-into-wet) on rough-surfaced paper.

Interior light

John Lidzey is fascinated by lighting effects in interiors, and has painted a great many room settings, some with figures and some without. For *Girl on Stool*, he has posed his model so that she is illuminated by strong side lighting, providing an exciting range of tonal contrasts. He often uses mixed-media techniques, and here has overlaid wet-in-wet washes with crosshatching in conté crayon. The highlights were reinforced with white gouache, which creates a softer effect than reserving white paper.

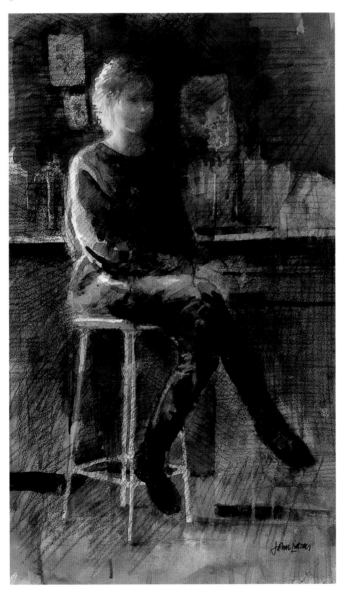

Tutorial **Working from sketches**

David Curtis works directly from his subject, whenever possible, and for a complex subject like this one, he makes a series of location sketches and completes the painting in the studio. The secret of working successfully from sketches is to know in advance the kind of visual reference you will need. This selection of sketches made for the painting opposite shows how by using a combination of quick watercolors and pencil drawings with notes about color, Curtis has provided an ample storehouse of information. Notice that he never draws or paints figures in isolation; all the sketches are complete notes about the scene he intends to paint.

Using the sketches as the basis, he begins the painting with a careful drawing, after which he applies masking fluid to small highlight areas. He likes to work freely, and masking prevents laboring the paint when taking it around small, intricate shapes. Some of the highlight areas in the grass are achieved by mixing a small amount of white acrylic with yellow and green watercolor—which he finds increases the intensity of color.

The top two sketches, made in soft pencil, explore the tonal relationships, while the third (above) provides notes on color.

In the sketch above, emphasis is laid on the postures of the figures, while the sketch on the right explores the look of figures seen through the fabric of the deckchairs.

David Curtis
Bandstand, St James's Park

Index

Credits

While every effort has been made to credit contributors, Quarto would like to apologize should there have been any omissions or errors—and would be pleased to make the appropriate correction for future editions of the book.

All other illustrations and photographs are the copyright of Quarto Publishing plc.